Library Media Center
Carroll
1601 W
Westminster, Maryland 21157

WIT

W9-AFN-925

How to Paint
SEASCAPES

WATSON-GUPTILL
Artists
LIBRARY

How to Paint
SEASCAPES

Francesc Crespo

Watson-Guptill Publications/New York

Packen 915796 4.75

Copyright © 1987 by Parramón Ediciones, S.A.

First published in 1991 in the United States by Watson-Guptill
Publications, a division of BPI Communications, Inc.,
1515 Broadway, New York, New York, NY 10036.

Library of Congress Cataloging-in-Publication Data

Crespo, Francesc.
 [Cómo pintar marinas. English]
 How to paint seascapes / Francesc Crespo.
 p. cm.—(Watson-Guptill artists library)
 Translation of: Cómo pintar marinas.
 ISBN: 0-8230-2472-5
 1. Marina painting—Technique. I. Title. II. Series.
 ND1370. C7413 1991
 751.42'2437—dc20 90-49247
 CIP

Distributed in the United Kingdom by Phaidon Press, Ltd.

All rights reserved. No part of this publication may be reproduced
or used in any form or by any means—graphic, electronic, or me-
chanical, including photocopying, recording, taping, or information
storage and retrieval systems—without written permission of the
publisher.

Manufactured in Spain
Legal Deposit: B-30.142-90

1 2 3 4 5 6 7 8 9 / 95 94 93 92 91

Contents

Introduction

Francesc Crespo, the author of this book, is a true professional with years of experience. He has had over twenty exhibitions in Spain, Italy, and other countries; his drawings and paintings have won a number of prizes; and many of his works are in different museums. Francesc Crespo is a good friend—one whom I have known for many years. I have often been in his studio and had the privilege of watching how he draws and paints. Crespo always works standing up. He doesn't sketch out a painting beforehand. Instead, he starts right in painting with the brush. He works very quietly, concentrating and calculating, visually sizing up his subject. He observes a form, an outline. He holds up the brush and starts making dots to the right and left, determining the size of the sketch. Then he rehearses the drawing without actually sketching anything yet, just swaying his hand purposefully back and forth. Suddenly, he draws a line, sketches a contour, and starts painting in all directions. Francesc Crespo is indeed an artist's artist.

But Francesc Crespo is also a professor with a doctorate in fine arts, and until recently, he was the assistant dean of the College of Fine Arts at the University of Barcelona. I have had the opportunity to sit in on Francesc Crespo's drawing classes at the university. They were held in a large classroom, with over thirty students sketching a nude model. The students worked with rapt attention in a profound silence that was broken only by an occasional murmur and the scratching of charcoal on paper. Crespo circulated from one easel to another, commenting, correcting, instructing. "Watch out! The parts must be subordinate to the whole. It's not a good idea to concentrate on that hand, for example, and forget about the rest of the figure. You have to see it and do it all at once, all at once."

We have designed this book to be useful to all those who may one day feel the need to express themselves, to communicate their sentiments and emotions through form and color, to stand before nature and extract its infinite, eternal pictorial possibilities.

We have tried, above all, to make the amateur see the importance, in any form of art, of starting with a concept that is clear and yet broad and universal. At the same time, we have sought to avoid formulas and so-called easy solutions that inevitably work to the detriment of creativity and of true painting.

Therefore, in this book, we will present a natural and logical method for painting a seascape, always concentrating on substantive information and omitting the frills. Since the method described here can be used with any style or technique, it gives you free rein to paint *your* way and not somebody else's.

The book includes a short chapter that summarizes the history of seascape painting since its seventeenth-century beginnings in the Netherlands and a chapter that introduces the specific problems associated with this type of painting.

There is also a chapter on the basics of perspective and color theory, topics that are absolutely essential for advancing in any artistic medium, and a chapter that describes all the materials necessary for painting seascapes in oils as well as in watercolors.

To Francesc Crespo's knowledge and understanding as an artist and an educator, we at Parramón have added our knowledge and understanding as specialists in publishing books on how to draw and paint. The artists and editors of Parramón (Olmedo, Carrasco, Marfil, Queralt) and I have designed each page of this book with great care and obtained the necessary photographs as well as the drawings and diagrams on perspective and composition. I collaborated personally with Francesc Crespo in writing the final chapter of the book, which describes the painting styles of artists Teresa Llácer and Josep Sala.

You have in your hands the results of our joint efforts—a valuable tool for learning how to paint seascapes.

If, through this book, we succeed in

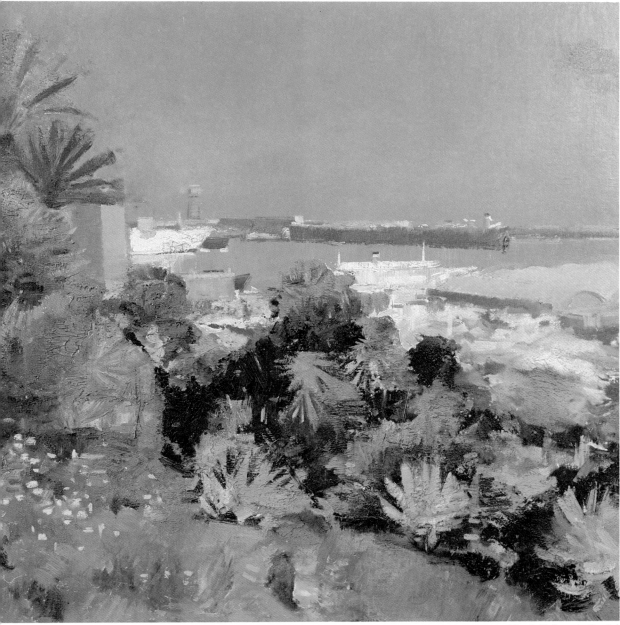

Fig. 1. F. Crespo, *Garden Overlooking the Port*. Palamos City Hall, Gerona.

stimulating your desire to paint, we will consider ourselves well satisfied. For painting is a noble activity—one that rewards the painter greatly in many ways. We wish you the best, then, as you study and learn, and feel certain that someday you'll look back and congratulate yourself on having decided to take up painting. Good luck!

José M. Parramón

The Powerful Attraction of the Sea

2

3

"Wherever there is water, the landscape comes alive."

Miguel de Unamuno

The sea, the sea... the myth of the sea.

Since the beginning of time, people have been powerfully drawn to the sea. Infinitely flat seascapes, beaches, cliffs, and peaceful coves have always stirred the soul deeply, arousing sensations of grandeur and infinity. The mystery of the sea, storm-tossed or majestically calm, excites the imagination and arouses fantasies. But for the artist, especially the painter, the sea irresistibly stimulates the creative impulse—the urge to realize a work of art—even if it's only a question of capturing the splendid variety of movement and color that the sea offers us in different regions and climates.

Have you ever stopped to think how contemplation of the sea's infinite expanses and the waves' rhythmic breaking, which surpasses the mere physical presence of a body of water, has the power to keep us endlessly absorbed and meditative—often inflamed with an inexplicable sensation that immediately awakens our entire being? It's as if a strange power impels us to cry out, to express ourselves... with a brush.

Someone once compared the magnificently flat and simple surface of the sea to the "pure and perfect harmony of Bach and Haydn." It is an apt comparison, suggesting the most sublime intuitions of beauty.

The sea. What a wonderful theme for a painting!

Figs. 4 and 5. J. Sorolla, *The Port of Valencia.* Sorolla Museum, Madrid. J. Mir, *The Port of Tarragona.* Private collection, Barcelona. The sea has always attracted the great painters. Observe how these two masters of color have interpreted the port theme.

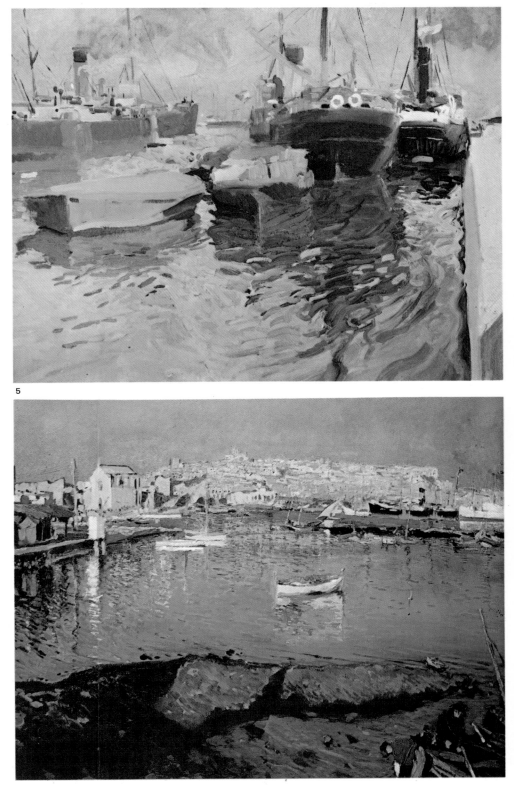

The Powerful Attraction of the Sea

Ports come in all sizes and shapes, ranging from the ports of major cities, with enormous freighters and ocean liners and navy vessels anchored, with little tugboats here and there, and with all sorts of people bustling about, to the small fishing ports of coastal villages and towns, busy the whole day long, to the ports frequented by sports enthusiasts, where speedboats and sailboats are tied up. Because of their rich assortment of forms and colors and their powerful marine ambience, ports offer wonderful themes that have always inspired painters everywhere. In short, a walk through a port during working hours makes for an interesting experience— one that can later be recreated in many ways on canvas.

6

The following chapter provides a brief overview of how seascape painting has evolved throughout history. We will attempt to show how this same general theme —seascapes— has been portrayed with very different forms and colors, depending on the unique circumstances of each historic period. In artistic terms, we would say that seascapes have been "handled" in a wide variety of ways.

7

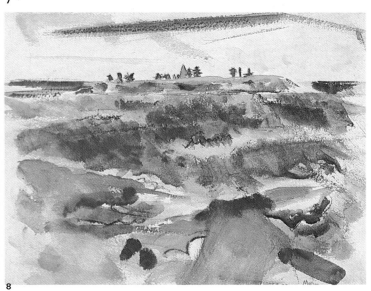

8

Figs. 7 and 8. J. Marin, *Off Stonington*. 1921. Columbus Museum of Art, Ohio. F. Zobel, *Beach*. 1973. Modern Art Museum, Cuenca, Spain. Modern art in its various styles has also received inspiration from the sea.

A Suggestive and Subjective World

Painting is a unique creative act. Because it responds to subjective and personal criteria and moods, painting is likewise open to subjective and personal interpretations. But at the same time, painting —good painting—possesses an extraordinary power of communication. It has a subtle and profound power that enables us to share all those purely aesthetic, lyrical, and dramatic emotions and experiences that humans find so necessary and gratifying. I sincerely believe, then, that there definitely is such a thing as a painting with a "message." And precisely therein lies the importance of painting. Furthermore, each artist, each painter, "sees" the painting in his or her own way. True artists don't copy nature; rather, they interpret it according to their particular convictions, beliefs, and ways of understanding life. And just as musicians communicate their ideas through notes and writers do through words and sentences, so it is with painters. They express themselves in the medium that is uniquely theirs, that is their raison d'être —form and color. This accounts for the extraordinary richness of art, always renewing itself, always surprising, always expressing itself differently in each individual—as infinite and variable as life itself, as unquenchable as the human spirit and intellect.

Thus it is that the world of the sea, of nature—so compelling and suggestive— is transformed into something equally attractive and fascinating: the world of painting. Painting, in short, is a universal language—one capable of uniting people and reconciling their spirits.

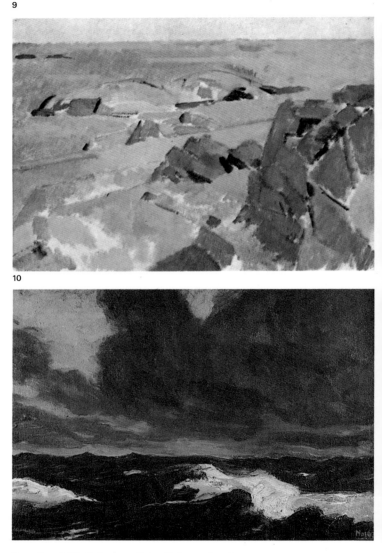

9

10

Figs. 9 and 10. K. Isakson, *Sälhundön Landscape*. Stockholm National Museum. E. Nolde, *The Sea*. 1930. Tate Gallery, London. Subjectivity is a major component in good painting. The true artist interprets nature freely.

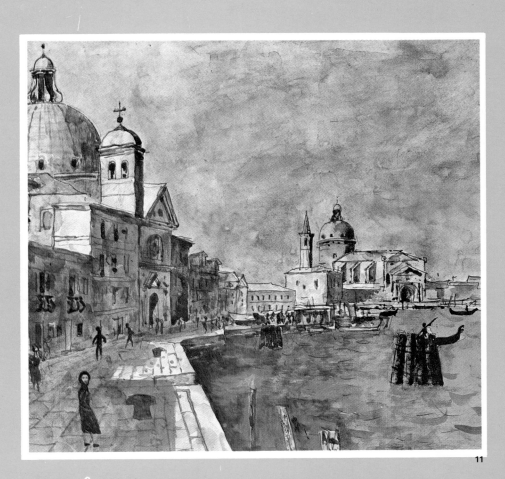

THE HISTORY
OF
SEASCAPE PAINTING

Seascape Painting Prior to the Seventeenth Century

Fig. 11. Roland Oudot, *Venezia: La Gindecca.* Albert Blaser Collection. Geneba.

Fig. 12. C. Lorrain, *The Port and Queen Saba's Embarkation.* National Gallery, London.

Seascape painting didn't really exist as an art form per se until the seventeenth century. Before that, nautical motifs were merely an adjunct to the principal theme: the human figure in action, in its function as a teacher of moral and spiritual values. Although certain nautical references can be observed in Egyptian and Greek paintings, Roman mosaics, Romanesque murals, and Gothic panels, these references are almost always little more than symbolic. The Renaissance created a sublime art, in which the concepts of order and beauty were the prime force underlying the seething ferment of humanism. But the theme of the sea in its true dimensions was still relegated to the role of a mere compositional detail or, at most, an illustrative reference. The great Florentine masters, the painters of the Siena school, even the great masters of a maritime power such as Venice only used the sea as a backdrop in those extraordinary works whose central theme was the human figure, often displayed in a formidable architectural setting.

In fact, the sea, like interior landscapes, did not become a principal subject and central motif of paintings until the seventeenth century. It was the Dutch and Flemish masters of that century who realized the immense artistic possibilities inherent in all aspects of nature. Thus, the spectacle of this external reality—contemplated with humility and devotion, and with the pure delight of capturing forms and colors, lights and shadows, rather than with the idea of extracting metaphysical or moral lessons—emerged as the principal theme. As time passed, the genre of seascapes would also contribute to revolutionizing the art of painting with the advent of impressionism.

12

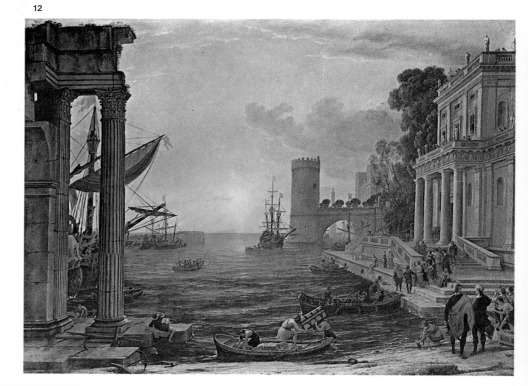

Pioneers of the Genre

Fig. 13. N. Poussin, *The Four Seasons* (Winter). Louvre, Paris.

Fig. 14. Willem van de Velde, *Calm Waters*. Mauritshuis, The Hague.

It might be said that a love of the sea as an artistic motif began with the French painter Claude Lorraine (1600-1682). His were conventional classic compositions in the style of Poussin, in which water often appears as a fundamental thematic element. His port scenes are particularly interesting. They show sunlight shimmering on the sea's surface, with airy ships outlined against a tall sky tinged with shades of pink, yellow, and salmon. The overall effect suggests a delicately enveloping atmosphere.

13

14

Pioneers of the Genre

Jan van Goyen (1596-1656) and Jacob van Ruisdael (1628-1682) were two of the most important landscape and seascape painters of the Dutch realist school. Their influence even extends to the development of nineteenth-century landscape painting. The most salient characteristics of Goyen's seascapes are the extremely low horizon and a broad and simplified treatment in which the colors are nearly monochromatic. For his part, Ruisdael, in his final works, already exhibited decidedly dramatic and romantic tendencies. Perhaps his best works are the typical Dutch landscapes in which light —in the form of rays of sunshine filtering capriciously through clouds— constitutes the element that unifies the scene and infuses the whole with a powerful internal vitality. Ruisdael's works influenced the English landscape artists of the eighteenth century and later the Barbizon painters.

In this context, we should also mention Willem van de Velde the Younger, who was born in Holland in 1633 and died in London in 1707. Born into a family of painters, he established himself in England, together with his father, and became the king's official painter of maritime themes. Since he produced over six hundred paintings and was considered to be the most important seascape painter of the Dutch school, he was an extremely influential figure, who is with good reason regarded as the father of English seascape painting.

Fig. 15. Jacob van Ruisdael, *The Windmill of Wijk*. Rijksmuseum, Amsterdam.

Fig. 16. Jan van Goyen, *Boats in a Calm Sea*. Art Institute of Chicago.

15

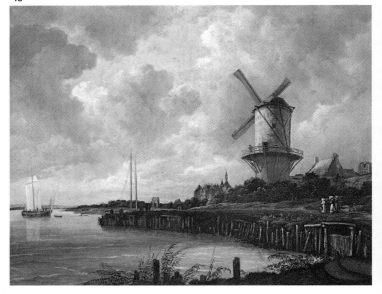

16

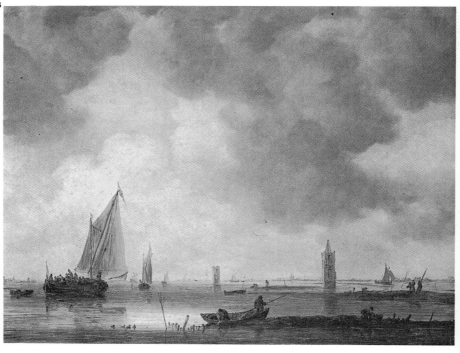

Venice: Canaletto and Guardi

Antonio Canal (1697-1768), known as "Il Canaletto," is another important master who was born in Venice and did most of his work there. Like Willem van de Velde the Younger, he also moved to England, where his works were enormously popular. His fame reached such heights that it was suspected (with good cause) that counterfeit copies of his works were being produced even during his lifetime. Il Canaletto's views of the city of Venice are extremely detailed, generally in warm tones, and reflect the special attention that he paid to the overall effect of atmosphere. A highly accomplished artist and etcher, he is known to have employed the camera obscura[1] (a device commonly used in the eighteenth century) to do preliminary studies for his paintings.

Yet another Venetian painter, Francesco Guardi (1712-1793), who also specialized in Venetian port scenes, opened up the genre further by giving light a more definitive value than Il Canaletto had done and by utilizing a freer and more abbreviated style. Because many critics have pointed out Guardi's influence upon the impressionists, the importance of his work has been reassessed. Like other European artists of this period, Guardi painted commissioned works for English clients.

Fig. 17. Canaletto, *The View of San Marcos Seen from San Giorgio.* The Wallace Collection, London.

Fig. 18. Francesco Guardi, *Venice's Grand Canal.* Alte Pinakothek, Munich.

17

18

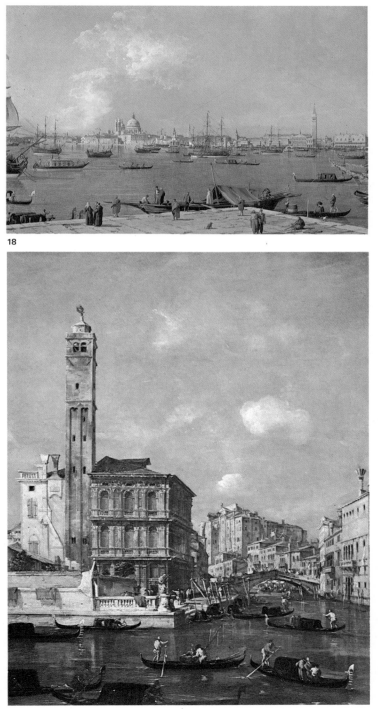

1. The camera obscura (literally, "dark camera") is a mechanical device that permits the outlines of a sketch to be drawn precisely. Invented in the sixteenth century, the camera obscura consists of a small box containing a carefully arranged series of lenses and mirrors. The image passes through the lenses and is then reflected by the mirrors onto a sheet of paper. All the artist has to do is take a pencil and trace the outline that appears on the paper. Sometimes it is possible to detect the use of a camera obscura to produce a drawing because of a certain telltale distortion in the outlines of the resulting figures.

Eighteenth-Century England

Because eighteenth-century England was an island nation with enormous colonial and maritime power, the English attached great importance to everything involving the sea. Not surprisingly, it was in England that seascape painting took root so strongly as to become a typical genre. It can be said that English painting reached its fullest expression with seascape painting, which best represented an aesthetic sensibility that became widespread throughout the eighteenth century and has lasted even until modern times. Paintings of this genre tended to depict either vessels under full sail navigating through calm seas with the wind in their sails and a flag flapping jauntily or ships battling heroically against powerful swells that threatened to sink them. During two centuries, many painters devoted themselves to this type of anecdotal and descriptive work. Although the great majority of these artists were highly competent draftsmen who depicted ships accurately and in great detail, their works were far removed from true painting. Nowadays, such works are valued by auctioneers and collectors primarily for their painstaking detail and indisputable historical value.

Nevertheless, given the circumstances of eighteenth-century English life, it was natural that certain English artists would feel called upon to revolutionize the art of seascape painting. These individuals became the precursors of the impressionist movement, which crystallized in the last third of the nineteenth century. Above all, great advances occurred in watercolors during this period.

TURNER

Joseph Mallord William Turner (who was born in London in 1775 and died in 1851) started out as an outstanding draftsman and watercolorist. However, in 1797, he exhibited his first oil paintings in the British Royal Academy. These works were noticeably influenced by Dutch seascape paintings and, to a certain extent, by classic historical paint-

ings. Surprisingly, this style gave way to an extremely original and "modern" approach in which an unrestrained orgy of light and color predominated.

Turner made a number of trips to Italy and other places. In Venice he did a watercolor and gouache series in which he achieved extraordinarily magical lighting effects that are truly without equal. Turner was a very versatile artist (in addition to the aforementioned works, he also produced fine etchings, based for the most part on his travels). Although his work was controversial during his lifetime, Turner has since been recognized as an enormously important and influential painter. He was the first great romantic, who knew how to use his rich palette of whites, yellows, and blues to create a powerfully evocative effect, simultaneously poetic and dramatic. Turner is indeed the master of mists, of shifting light, of damp fogs, of shimmering waters.

Fig. 19. L. Backhuysen, *Dutch Merchant Ship Battling the Stormy Coast*. Formerly in the collection of the Earl of Onslow.

Fig. 20. J.M.W. Turner, *Venice. A View of Old Saint George from the Customs Building*. British Museum, London.

Fig. 21. J.M.W. Turner, *Waves Breaking on a Leeward Coast*. Tate Gallery, London.

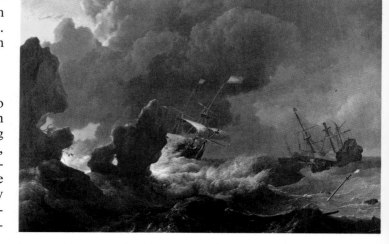
19

20

21

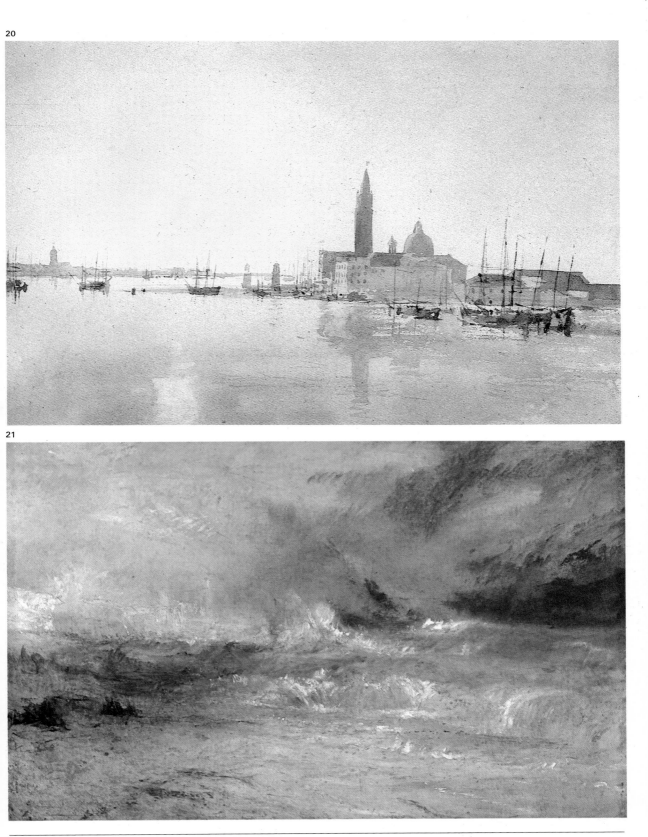

Nineteenth-Century England

Among Victorian painters, Richard Parkes Bonington (1801-1828) and John Sell Cotman (1782-1842) were notable for their seascapes. Bonington made his influence felt on painters of the romantic movement, which began in 1824 in the famous Paris Salon, in which Bonington participated. His landscapes and seascapes are notable for the freshness and spontaneity with which he resolved problems of color. Cotman, a friend of Turner's who worked in both oils and watercolors, was a restless artist who produced some of the best English seascapes of the last century.

Fig. 22. J. Sell Cotman, *The Brigantine Losing Her Mast.* British Museum, London.

Fig. 23. R. Parkes Bonington, *Boats on the Beach.* British Museum, London.

22

23

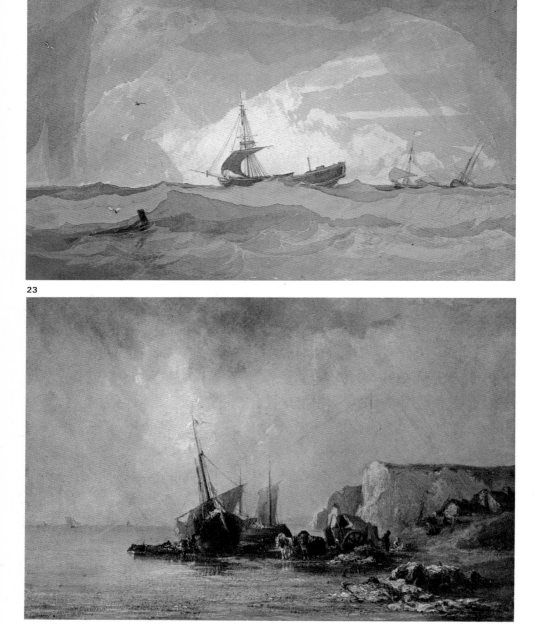

The Impressionist Movement

In the 1860s, a group of young painters emerged from Paris and flocked to France's northern beaches: Sainte-Adresse, le Havre, Dieppe. They had been associated with the artists who painted landscapes in the open air in Fontainebleau and later created the celebrated Barbizon school of landscape painting. Among these newcomers were Monet (1840-1926), Bazille (1841-1870), Sisley (1839-1899), and two older painters: Jongkind (1819-1891) and Boudin (1824-1898), who had already been painting in the open air for some time. Thus it was that these artists "discovered" that the depth and special concavity of the horizon in all its intensity could be incorporated into their painting. They found, too, that painters could make the features and accidents of a particular natural scene the principal motif of their work —in contrast with romantic painting, which still employed the painting as a vehicle for depicting strong emotions, for conveying a message. The impressionists sought a pure and simple representation of nature using natural forms and colors, lights and shadows; they tried to faithfully capture atmospheric states, with the calm or stormy weather itself becoming the true protagonist of the painting.

Fig. 24. J. Barthold Jongkind, *Sainte-Adresse Beach.* Musée d'Orsay, Paris.

Fig. 25. C. Monet, *The Argenteuil Sailing Race.* Musée d'Orsay, Paris.

24

25

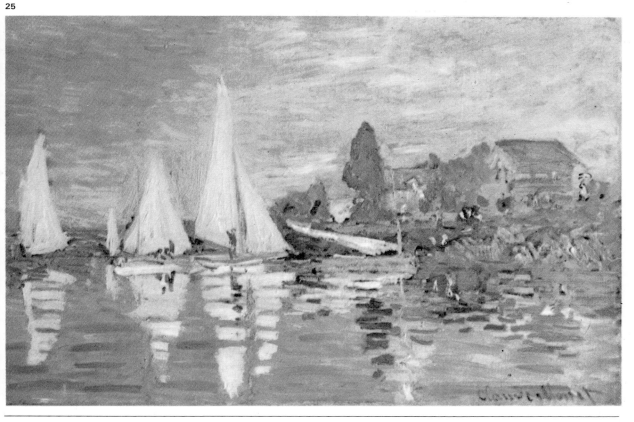

The Impressionist Movement

26

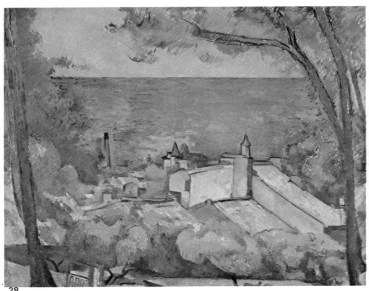

27

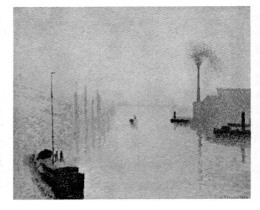

Fig. 26. P. Cézanne, *The Sea at Estaque.* Private collection.

Fig. 27. C. Pisarro, *Mist. Ile Lacroix, Rouen.* Philadelphia Museum of Art, John G. Johnson Collection.

28

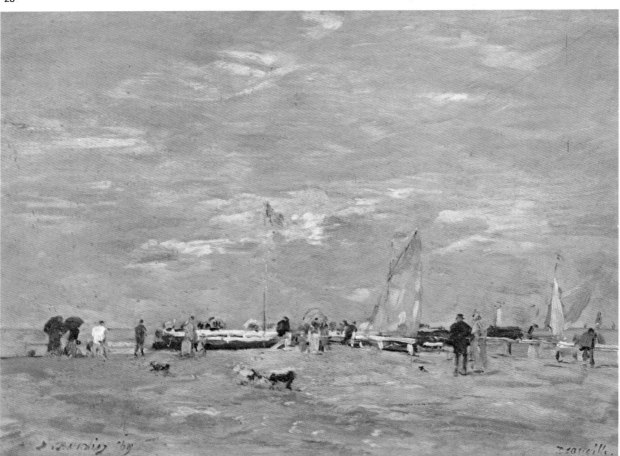

Fig. 28. E. Boudain, *The Pier at Deauville.* Musée d'Orsay, Paris.

29

The birth of impressionism, perhaps the most important "movement" in the entire history of painting, had a critical impact on the subsequent evolution of seascape painting. Impressionism represents the triumph of light, and therefore of color. Light vibrates, moves, suffuses everything. Light and color really determine all the shapes and vistas. Impressionist painters were strongly influenced by the new scientific theories about light and color, including those of French chemist Michel-Eugène Chevreul (1786-1889). They understood that the color of a form can only be found in a half-tint, that the color of that form's shadow always contains color that complements the illuminated part, that a shadow also always contains blue, that colors can be amplified and brightened when they are properly juxtaposed. In short, the impressionists adopted new and revolutionary concepts that, to a great extent, remain in effect to this day. In addition to the aforementioned artists, impressionist seascapes were also painted by a number of individuals who

later became famous, including Pissarro, Renoir, Cézanne, Lépine, Guillaumin, Colin, Morisot, and others not as well known. The fact that great museums throughout the world jealously guard the works of the impressionists testifies to the extraordinary adventure that began on the beaches of Normandy.

Fig. 29. C. Corot, *Rocks on the Seashore*. 1870. Mesdag Museum, The Hague.

Fig. 30. P.A. Renoir, *The Sailboats of Argenteuil*. 1873. Portland Art Museum, Oregon, USA.

30

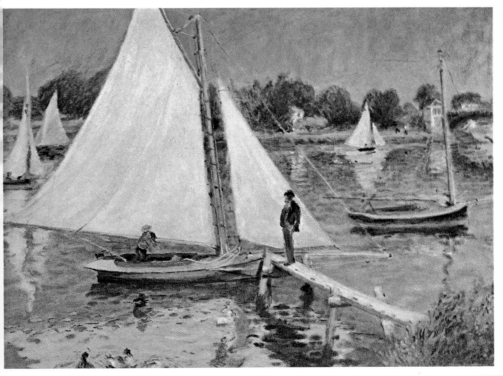

Japanese Printmaking and Pointillism

In this brief historical summary, we should point out, albeit only in passing, the impact of eighteenth-century Japanese printmaking upon the development not only of impressionism but of all subsequent painting. The originality of the composition, in which the figures were cut off along the bottom and side margins of the painting, the brilliant colors in flat tones, and the concise treatment of the forms surprised avant-garde European artists.

A truly outstanding painter of this period was the North American James McNeill Whistler of Massachusetts (1834-1903). After studying and working in Paris, he settled in London, where he engaged in disputes and lawsuits with critics and the public, thanks to his unyielding stance in defense of the artist's freedom and social supremacy. He, too, was greatly influenced by Japanese printmaking. In his series of "nocturnes" in this style, he introduced a new dimension in the art of representing lights, sparkles, and reflections on the surface of water.

Impressionism began to evolve toward an increasingly scientific and calculated style. Pointillism —or "divisionism," as its followers preferred that it be called— was based fundamentally on the juxtaposition of two primary colors. For example, when blue and yellow are juxtaposed, the human eye blends these two primary colors to create the impression of a more pure and brilliant version of the secondary color green. The pointillists proceeded in the same fashion with all the rest of the colors of the spectrum as well as with the grays. Using this technique, they were able to subdivide the shady areas of a painting into colors that complemented those in the corresponding lighted areas. The two champions of this new style were Georges Seurat (1859-1891) and Paul Signac (1863-1935), who heatedly defended its theories. Of course, these theories were also followed by a group of artists who were unable to employ the techniques successfully in their works. Since nautical themes lent themselves especially well to pointillist experimentation with lighting effects, both Seurat and Signac did create a number of interesting seascapes.

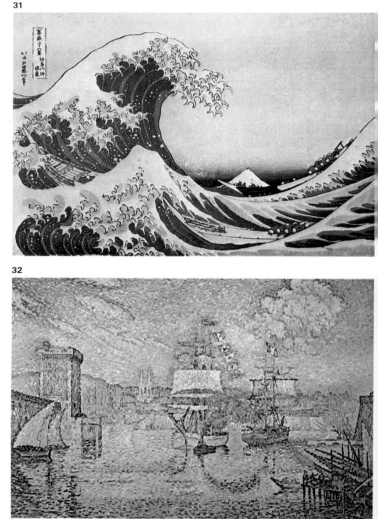

31

32

Fig. 31. Hokusai, *The Hole in the Depths of the Sea*. British Museum, London.

Fig. 32. P. Signac, *The Port of Marseille*. Museum of Modern Art, Paris.

Expressionism

Toward the end of the last century, art entered into a process of constant change, which has continued to the present day. The freedom of expression that artists so stubbornly demanded produced two parallel movements: expressionism and fauvism. The influence and transcendence of these two movements continues unabated, since many artists in one way or another move between them in an endless process of aesthetic derivations.

Expressionism seeks maximum stylistic expressivity by exaggerating and distorting line and color. It represents, in a certain sense, the deliberate abandonment of the naturalistic emphasis so common in impressionism in favor of greater simplification of a painting's major elements—an approach capable of producing great emotional impact. The expressionist movement was begun by Vincent van Gogh (1853-1890) and Paul Gauguin (1848-1903), two of the greatest artists of all times. Despite their difficult

33

lives, they created a highly personal art, which, thanks to its authenticity and universality, has had a permanent impact on all subsequent artists. Another great artist, Paul Cézanne (1839-1906), a contemporary of van Gogh and Gauguin, started out as a proponent of impressionism. However, in light of the evolution evident in his later works, he can definitively be classified with the expressionists. Cézanne's influence on all modern art, not just on painting, has been enormous. From Cézanne's theories and, above all, from his works, which pointed toward an infinite number of innovative possibilities, are derived almost all the movements and aesthetic "isms" of the twentieth century, including, in particular, the cubist art inspired by Picasso.

Fig. 33. Vincent van Gogh, *The Sea at Santa Maria* (detail). Pushkin Museum, Moscow.

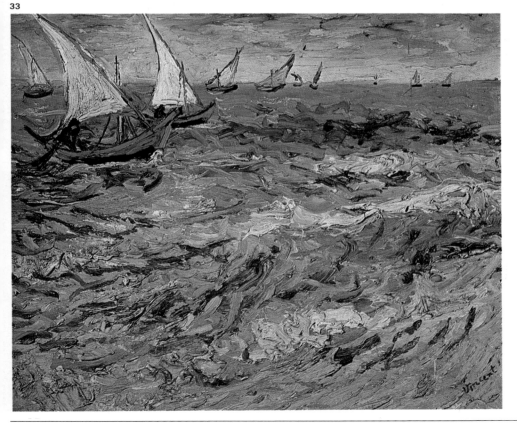

Fauvism

Fauvism began in 1905 in the celebrated Autumn Salon in Paris, where Matisse (1869-1954), Marquet (1875-1947), Derain (1880-1954), Vlaminck (1876-1958), and other lesser-known artists exhibited their paintings. The exhibit caused a terrific uproar because of the extreme distortions, flat forms, and violent colors of the works. One critic was moved to call these artists *les fauves*, which means "the wild beasts." Fauvism is in fact a form of expressionism, in which the picture is formed by applying pure colors and using flat forms, without shaping the figures or distinguishing between light and shadow. Although the group soon dispersed, with a portion of its members joining some of the new movements that soon popped up, the fauvists' work is still of interest strictly from an artistic standpoint.

34

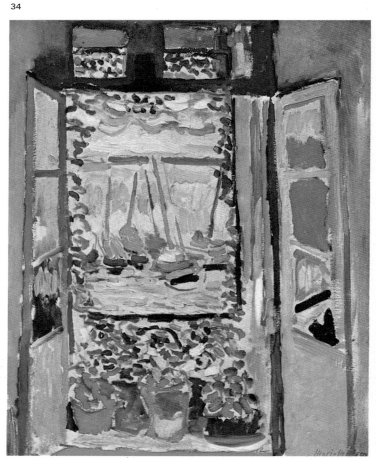

35

Fig. 34. H. Matisse, *Open Windows in Colliure*. 1905. John Hay Whitney Collection, New York.

Fig. 35. A. Derain, *Reflections on the Water*. Annonciade Museum, Saint Tropez.

The Twentieth Century

After fauvism came an uninterrupted series of artistic movements and "isms": cubism, constructivism, futurism, metaphysical painting, surrealism, etc., until we arrive at abstract art, whose proponents regard forms and colors themselves as having inherent aesthetic values, entirely apart from a painting's theme or motif. In all these aesthetic movements, we continue to find, in one way or another, references to the sea and things related to it, even when the sea isn't the principal subject of the work. Painting currently finds itself in a state of restlessness and disagreement, constantly seeking affirmation, whether it be in the strict sensuality of pictorial enjoyment by means of the struggle to shape beautiful visual effects, or whether it be in a considerably more subjective creative process, in which all descriptivism is eliminated in favor of the freest and most unencumbered expression of the artist's most intimate sentiments.

With respect to seascape painting, the watercolor masters of the United States deserve special mention. Heirs of the great English watercolorists of the eighteenth and nineteenth centuries, the American artists soon became known for their fresh, direct interpretation of reality, as well as for their truly admirable mastery of the technique. To illustrate the level of achievement that had already been reached toward the end of the last century, we need only mention Winslow Homer (1836-1910); Whistler himself, who had worked with the impressionists; and John Singer Sargent (1856-1925), who was also a famous portrait painter. In the present century, watercolor has come into its own and has, in all styles, taken its rightful place beside other pictorial techniques. Among twentieth-century artists, the following names deserve mention: Julio Quesada, Miquel Ciry, Maurice Prendergast (1859-1924), Charles Reid and Frederic Lloveras.

36

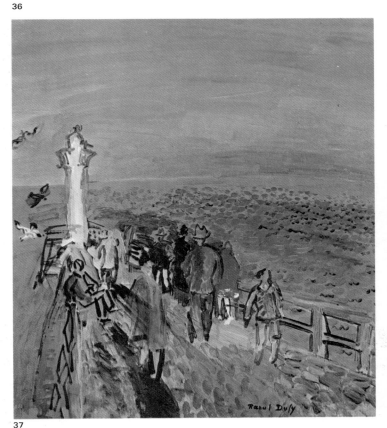

37

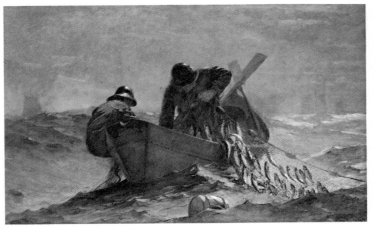

Fig. 36 Raoul Dufy, *Deauville*, 1929. Museum of Art, Bâle.

Fig. 37. W. Homer, *Taking out the Net*. 1885. Art Institute of Chicago.

The Twentieth Century

38

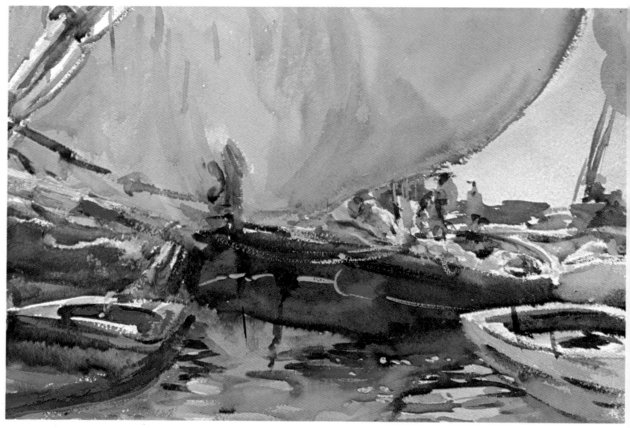

39

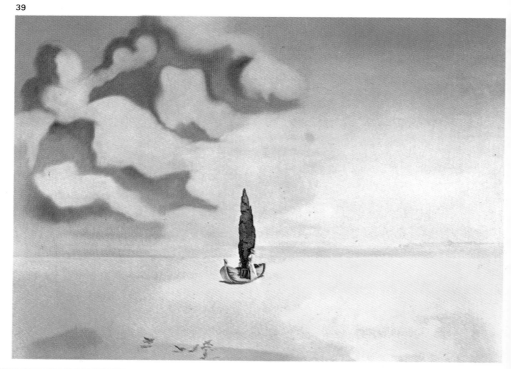

Fig. 38. J.S. Sargent, *Boats with Melons*. 1909. Brooklyn Museum, New York. (Purchase.)

Fig. 39. S. Dali, *Vision of My Cousin Carolinetta on the Beach at Rosas*. 1934. Private collection.

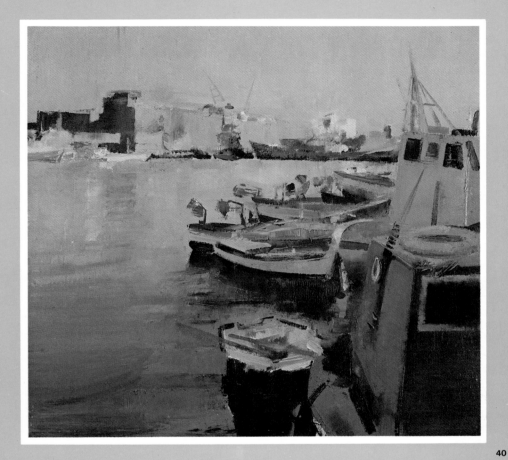

40

BASIC CONCEPTS
—————AND—————
GENERAL CRITERIA

Light and Paint

"In order to paint a bottle, it is better to express its substance in a combination of colored shapes, as it is worth more to be a glass maker than a painter."

Juan Gris

We have seen how the theme of the sea has been interpreted differently, depending on the period and the artist. But all paintings, and especially seascape paintings, contain a common denominator that dominates: light.

Light illuminates the natural setting, it conditions and identifies every climatic and environmental moment, and it determines how we see all of nature's colors. Now, as you well know, natural color, authentic color, is interpreted and expressed through various mediums: oil, watercolor, tempera, etc. That is to say, the colored substances that constitute the physical reality of a painting itself. It is quite clear that nature's colors are not the same as those seen in a painting and that their chemical composition is also not the same. Even though it might seem unnecessary to mention, this should not be forgotten by anyone who wishes to become a painter; its importance will soon become evident. On the following pages, we will take a look at color theory and its effects.

The first concern of the painter should be to get the most from using basic painting techniques. For example, through an understanding of color which has its own well-defined characteristics, the painter can achieve his or her aesthetic objectives. This doesn't mean, of course, that theme or concept should be ignored, for as "realistic" as colors might be, each theme must be uniquely pressed by that individual artist. Painting is about, above all, paint, not the objects being painted.

Therefore, Juan Gris (1887-1927) was right when he said that painting is trying to represent as closely as possible the quality and substance of the forms represented in an undoubtable *trompe l'oeil*,[1] and that the painter ought to study the trade of craft that he or she is trying to imitate before dedicating himself or herself to painting.

But we continue to see all this in a better light.

1. When the artist paints in photographically realistic detail, making an obviously excessive use of descriptivism and illusionist devices, it is said that he or she is creating a "trompe l'oeil" painting, which means literally in French "deceives the eye."

Fig. 41. J. F. De Le Motte, Private collection, France. This example of tromp l'œil has all the possible effects of a relief, using imitative technique, and shows the exaggerated detail characteristic of this philosophy and style of painting.

41

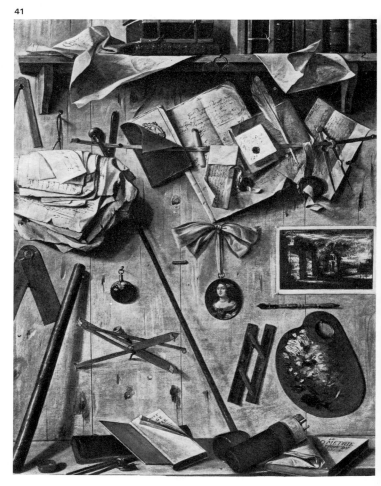

42

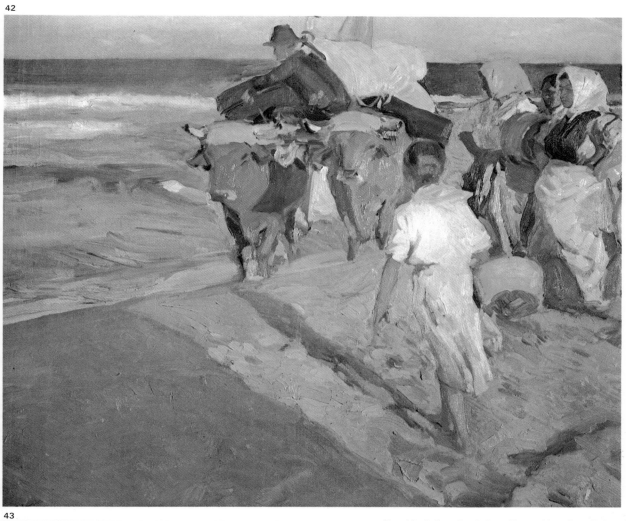

43

Fig. 42. J. Sorolla, *Pulling the Boat Out*. 1916. Private collection. The painting's substance, oil, is more important here than the theme or motif.

Fig. 43. A. Sisley, *Riberas* (detail). Saint-Mammés. The brushstroke is expressive. The color is applied spontaneously with ease.

The Painting

A painting, like all other fine art, contains a measured unity where all the elements must integrate harmoniously, all things considered, including the nature of the painting and its intrinsic quality. In a word, a painting must be "organized." Nature, including at times that which has been modified by man, is presented to us in such an organized and harmonic way that it is in accord with its own natural laws. But the artist, from the moment that he or she chooses his or her scene or a portion of it, selects and organizes forms and colors, "composes" the work in accordance with his or her aesthetic concept, and interprets nature within the confines of the painting's rectangular canvas.

Our goal is to translate what we see and feel according to the laws of art, which as we know are very liberal and extraordinarily versatile. And that which at first might seem to be a conditioning factor does not represent, under any circumstances, the work's essential characteristic. This is where the secret lies.
Eugène Delacroix (1798-1863) wrote in his diary: "You are the theme. Your impressions, your emotions are what count when in the midst of nature. Look inside yourself, not around you."

Fig. 44. A. Marquet, *The Beach at Fécamp*. 1906. Museum of Modern Art, Paris. All the elements in this painting adhere to the pictorial "laws."

Fig. 45. V. van Gogh, *Boats at Saintes-Maries*. 1888. Rijksmuseum Van Gogh, Amsterdam. The chromatic harmony comes from this great Dutch painter's particular way of seeing things so that he could capture a total unity in his painting.

44

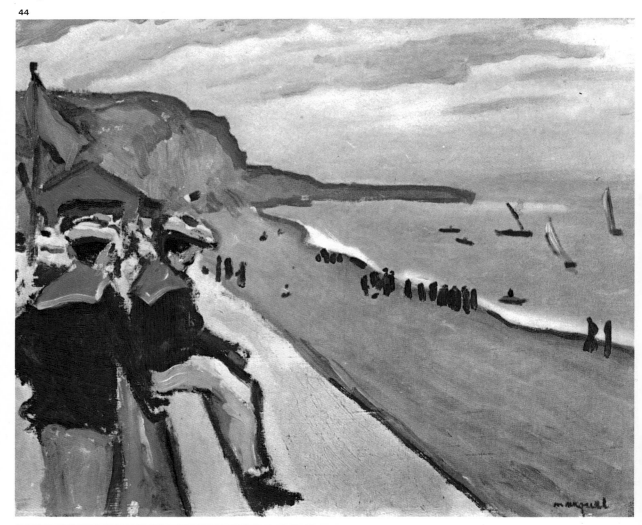

Even more direct, Maurice Denis (1870-1943), a French painter and student of Paul Cézanne (1839-1906), also put it very clearly: "A painting, before being a horse in battle, or a naked woman, or any other anecdote, is essentially a flat open surface of colors joined together in an ordered fashion."

Study reproductions of great paintings and whatever you can see at galleries or in museums and you will see that as much as the paintings may differ, the idea of a total unity is present in all of them. Nothing is missing, nothing is leftover. More than reproducing nature, and much less copying it (if this were even possible), the artist has intended above everything and despite how realistic the painting might be, "to create the painting," and his or her success permits us to talk about works of art.

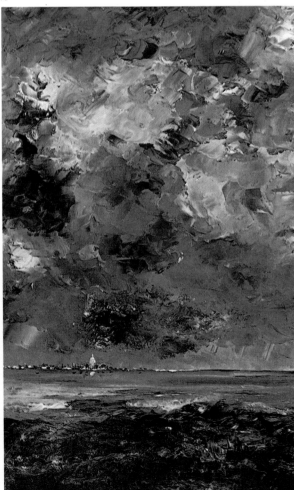

Fig. 46. A. Strindberg, *The City*. Here, the range of gray-bluish-greenish color and the vigorous brushstrokes become the painting's true protagonists.

Fig. 47. N. De Stael, *Landscape*, 1959. Collection of Mr. and Mrs. David Solinger, New York. All concepts are valid for the interpretation of a seascape.

The Sketch as Foundation

It is not our intention here to define the word "sketch" or to exaggerate the importance of this discipline. We merely wish to emphasize a fundamental principle: The sketch has been and still is the organic structure by which all fine art is created and constructed.

Indeed, any visual idea or thought can be expressed through a sketch and it is possible to invent and develop shapes that contain many concepts. With just a few lines or tracings we can create any natural shape or one that is a result of fantasy or imagination. Through the sketch we are able to "see" immediately what our work will be like, creating a composite synthesis that permits us, before actually painting, to rectify things here and there as we see fit, changing part or all of the planned painting. The sketch is indispensable to painting. But, curiously enough, it is thought that in landscape or seascape painting the sketch has little importance, almost as if it were not necessary to have any knowledge of the sketch in order to dedicate oneself to these genres. It's a matter of "oh well... a tree more to the right or to the left, a pile of leaves more or less, a horizon higher or lower, not much mat-

ters.... It's not the same as drawing a figure or a head." Well, clearly it's not the same, but the sketch is always needed to organize an artistic surface and, even more importantly, the sketch must be present in the internal structure of each form and in each group of forms represented.

There is only one sketch. The rules and fundamental principals of the sketch are universal and they are useful for drawing all subjects in all mediums and for all themes: figurative, still life, landscape, seascape. Draw whatever you can: figures, inanimate objects, trees. Pay special attention to all the shapes within view. When you paint your seascape all these experiences will have a positive effect on your composition and layout.

Figs. 48 to 50. The two sketches below are attempts to analyze elements that are included in the composition at right.

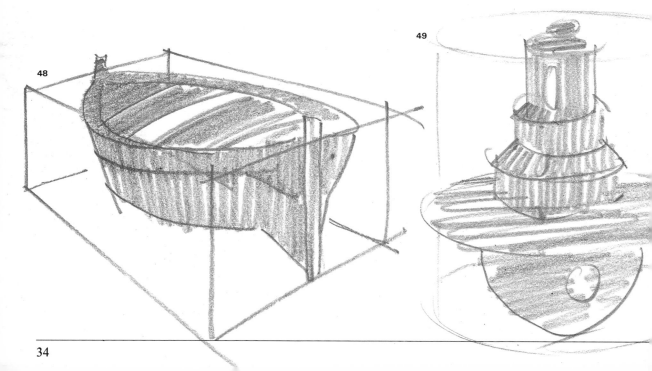

Cézanne's Lesson

"Every form is reduced to the shape of a cube, a cylinder, and a sphere."

Paul Cézanne

Cézanne's statement has become famous because it is much more than just words —it's a great truth. In fact, if you pay special attention to natural and man-made shapes, you will see that they do fit into cubes, cylinders, and spheres.

We should remember, in passing, that Cézanne's concepts and theories are considered the foundation of the cubist movement that grew out of a reaction to impressionism.

50

Color as Spectacle

"We look at nature in an ordinary light. An artist has to see it and paint it as something extraordinary and fantastic."

Marc Chagall

If it seems obvious that the high regard for color is present in all paintings, then this is even more true in painting sea-scapes, perhaps more than in any other genre. With all that sea themes offer us—such as cheerful colors and mul-ticolors of all types of boats on the water—nature in broad daylight offers us the best occasion for painting freely, without restrictions, indulging the imagi-nation and all chromatic sensitivity. The true painter, the one who feels color in-stinctively, won't be able to resist inter-preting the sea and all the complex splen-dor that it embraces. It's a truly fascinating, joyful experience. But let's consider this. It is easy to imagine that a seascape ought to be treated with strong, vibrant colors, emphatic and in-tense, as if a natural seascape were only attractive in optimal conditions of sun-light. This tendency exists, doesn't it?

51

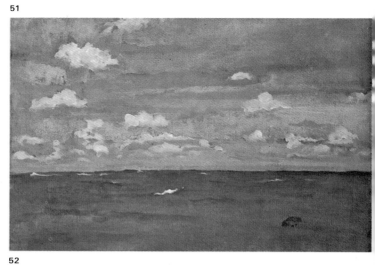

52

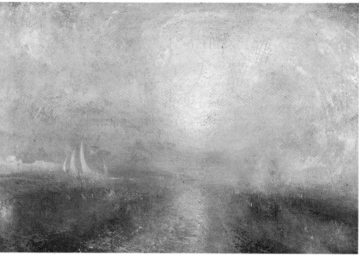

53

Figs. 51 to 53. J. Whis-tler, *Seascape*, 1893. Art Institute, Chicago. J. M. W. Turner, *Boat Near the Coast*. Tate Gallery, Lon-don. A. Derain. *The Lon-don Dock*, 1906. Tate Gallery, London. Color is everything in these three paintings. But it is also completely different in each one of them, de-pending on each artist's personal vision.

54

Fig. 54. C. Monet, *The Houses of Parliament.* National Gallery of Art. London. Grays, blues, and pinks are the true theme of this famous impressionist painting.

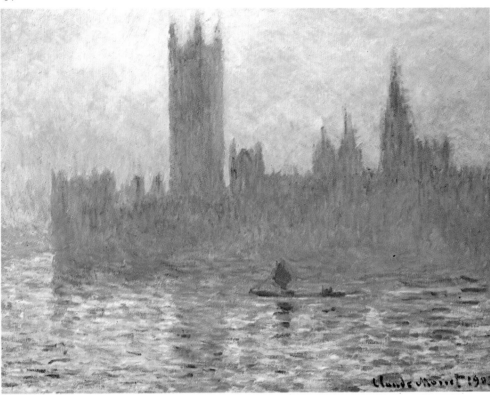

Nevertheless, when we examine the conditions of intense luminosity, where the most vibrant colors become grayer and grayer in infinite complexity, going off in the distance, we could almost assure you that in the foreground of our particular medium we are only going to find intense and saturated colors; almost as pure as when they came out of the tube. And this is what we refer to as the *naturalist* vision, depending on a specific concept and style of painting. As always, we are dealing with something relative and subjective that will depend upon each person's interpretation of nature as he or she relates to the pictorial laws discussed on the previous pages.

Sunless, cloudy days at the sea are also rich in their characteristic color and atmosphere. Color has no boundaries and the possible interpretations are practically infinite. Color creates an impressive spectacle. A spectacle in nature and, more importantly for us, in painting.

We do everything possible to translate this "spectacle of color," radiant and splendid or subtle and delicate, into a painting, in order to transmit to others the emotions and sensations that have impelled us to create this particular painting.

Look at the great paintings on these pages by four outstanding seascape artists. Color is everything and establishes itself as the true protagonist. Also, notice how different the paintings are in all respects. It is difficult to have a preference for one over another.

The Seascape Painter's Palette

As we will see later, even when the subject, or rather the light that illuminates the subject, determines the tone of the work and therefore, in some way, conditions our palette, you should know that you can obtain all the colors in nature with white and the three primary colors. We will discuss this later. For now, what we want to say is, an "ordinary" palette is enough for painting any seascape.

These days, working in whatever medium, there is an extraordinary selection of colors available. The manufacturers of the most respected brand names offer color charts with an abundance of different yellows, reds, greens, blues, and so on, all pretested and guaranteed. Although it may seem that all these colors are necessary in order to obtain good results, the experience of artists throughout time shows that a basic palette with a maximum of ten or twelve colors is adequate for all subjects and genres. Naturally, in some way, we are saying that this basic palette is the only one. Although we know that everything in art is relative, we believe this basic palette can help achieve our goals and therefore we advise using it.

Look at the color chart commonly used by professionals. There are a total of twelve colors, not including white and black. The obligatory colors, the three primaries: yellow, magenta, and cyan blue, in turn correspond with cadmium yellow medium, dark carmine, and Prussian blue. An ochre, some earth colors, a red, an emerald green, and another blue are included among others mentioned in the specific list of the color chart.

Notice that four of these colors, including black, have an asterisk indicating that they could be deleted from the list without diminishing its integrity. Note also how white is among the indispensables, while black could be left out under the condition that —well, we'll discuss that on the next page.

So, if we want to work with a specifically "seascape palette" we can add the following range of cool colors: light

55

OIL COLORS COMMONLY USED BY PROFESSIONALS

Cadmium yellow lemon*	Dark carmine
Cadmium yellow medium	Permanent green*
Yellow ochre	Emerald green
Burnt sienna*	Cobalt blue deep
Dark earth brown	Ultramarine blue
Light vermilion	Prussian blue

Titanium white
Ivory black*

ultramarine, azure blue, Veronese green or a blend, and cobalt violet. Look also at these colors in the corresponding chart.

We should point out that these colors are not absolutely necessary. Our needs are easily covered with the basic palette already described. But four or five of these colors, if used well, can help enrich our particular chromatic range and keep it clean.

As for the heated debate over the use of black, I want to express my opinion. Black is a wonderful, unique color, but you have to know how to use it.

56

Putting aside the theories of Chevreul and the impressionists, black is a color that if overused can be messy and ruin the overall harmony of a painting. Because of this, many teachers recommend that beginners take it off their palettes and substitute Prussian blue, dark carmine, and emerald green; or Prussian blue, dark carmine, and burnt sienna, which together make a perfectly valid black, having the advantage of being less messy but also having the disadvantage of giving a bluish or crimsonish tone if not mixed well. As a matter of fact, a similar problem occurs with white, or the opposite problem, if you will; that is to

say, we all know that if white is used improperly it can "bleach" the work. Therefore, we have no prejudice against black, but we must work carefully and sensitively with it. When the black and the white are of good quality we obtain a basic gray, receptive to a "dash" of any other color, hot or cool, which gives the gray a slight hue of artistic purity. Study the examples.

Fig. 56. Light ultramarine, azure blue, turquoise blue, Veronese green or a blend, and cobalt violet. Sometimes it is interesting to add another very specific color to the palette in order to achieve particular effects.

Fig. 57. With white or black, use warm or cool colors lightly to obtain an infinite number of subtle grays.

57

The Color of the Sea

Paul Cézanne left his ideas and opinions in his writings. There is one point that Cézanne makes that particularly interests me for its significance as a general summary of what we have been discussing up until now. It's the following: "I have discovered that the sun is something that cannot be reproduced, but can be represented."

With all the relativism that the color of any object implies—the way that nature is perceived always depends on the circumstances of the light conditions that allow us to see it—there are, perhaps, no colors more indefinite, versatile, and fickle as those in the sea. Homer talked about "a sea the color of wine," and other great writers have described a sea of this or that color, being brilliant, dark, or transparent. If the great thinkers and writers have seen such a variety of color and tones in the seascape water's surface, what will the passionate painters see whose desires are focused on trying to obtain the most beautiful harmonies and chromatic chords?

No, rightly said, there is not one particular color of the sea. I say this —even though I think you already know— in order to eliminate once and for all the kind of stereotyped idea that the sea is always blue or, maybe, green. Such a phenomenon occurs too frequently and you will see how these misconceptions spread through many other aspects of the painting where visible shapes are concerned. The sea can be blue, it can be green, or it can even be violet!

But there is a general principle that serves as a guide. The sea waters reflect the sky light in such a way that a bright blue sky can also pertain to a brilliant blue sea; a cloudy sky can be similar to a gray leaden sea. So, in a seascape, the sea and the sky must have a tonal and chromatic relationship. This does not mean that they must be the same color.

58

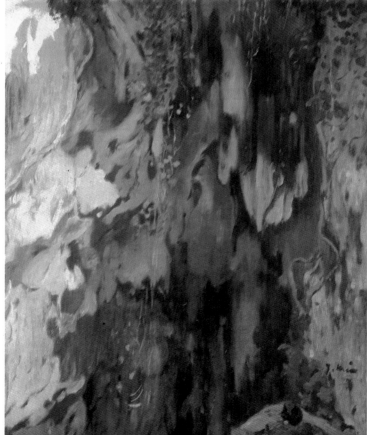

Fig. 58. J. Mir, *The Cave*. Trias Fargas Collection, Barcelona. In this painting the color of the sea has become dark and mysterious. Extraordinary richness of color has been caused by the reflection of rocks.

The light reflected from the sky onto the sea's surface is transformed into distinct tonalities of greater or lesser intensity. These are in the same "family" and are directly dependent upon the density or depth of the water and the way it is situated —far or near from the coast, and whether it is smooth, ripply, with a rush of waves, etc. I think this can also be easily understood.

Another thing to consider is that the color of the sea is always lighter closer to the horizon, because in the distance, where the sea and the sky meet in a trompe l'oeil, the light reflected is more intense and the colors seem the same. Next to the cliffs, where the sea is deep, the water has a darker and more intense color in an unequaled symphony of tones and nuances. Study the examples.

I advise you to take notes or make quick sketches of simple views on small, inex-pensive canvases. Draw a "piece" of sky and sea, or a "pinch" of the water against the rocks, the waves lapping quietly against the beach. Try to interpret the painting using the colors closest to what you are seeing without worrying about adjusting or harmonizing. I assure you that this is an exercise you will benefit from and enjoy. Above all it will make you think about doing more seascapes.

Fig. 59. F. Crespo, *Deserted*. Private collection. This painting was done at dawn with almost no light. The violet sky and the sea make the humble little boat seem even more deserted.

59

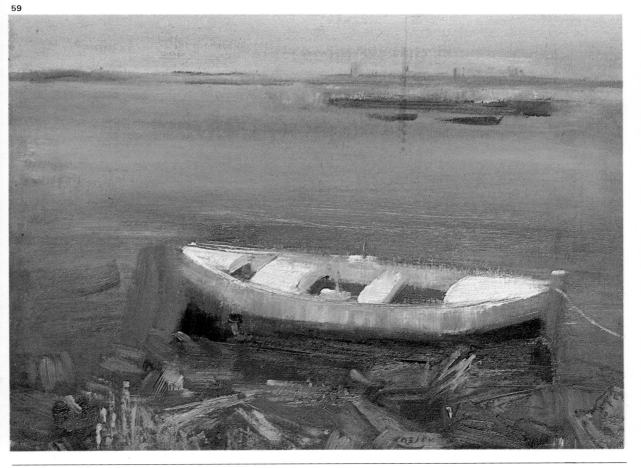

Contrasts of Color in the Sea

Hegel (1770-1831) wrote: *"In the real world all objects show a coloration difference by virtue of the atmosphere that surrounds them.... The farther away the object, the more it becomes discolored, the more undefined the shapes, because the contrast of light and shadow becomes more diffuse.*

It is ordinarily believed that the foreground is the lightest and the object farthest away, darkest, but this isn't so; the foreground is both the lightest and the darkest because the contrast of the light and the shadows closest to the greatest intensity makes the contours more defined."

In reality, Hegel, who was a German philosopher, wrote the above in his book *The System of the Arts*, discussing *aerial perspective.*[1] For our purposes the following considerations are helpful:

- In seascapes, as in all landscapes in general, the distances retreat and lose color, tending toward blue, violet, and gray.
- The foreground is always sharper and more contrasted than those areas in the distance.
- The warm colors come "close" to the shapes; the cool colors "retreat."

1. *Aerial perspective* shows us how to obtain the sensation of depth while working in a special way with color, the aerial-view atmosphere apparently modifies tones and tonal relationships while contrast diminishes according to the aerial-view distance and turns darker.

Fig. 60. J. M. Parramón, *Fisherman's Dock, Barcelona.* Study the discoloration of the tones as far as they relate to the horizon. The grays in the background are a definite contrast to the boats in the foreground, producing a sensation of atmospheric serenity.

60

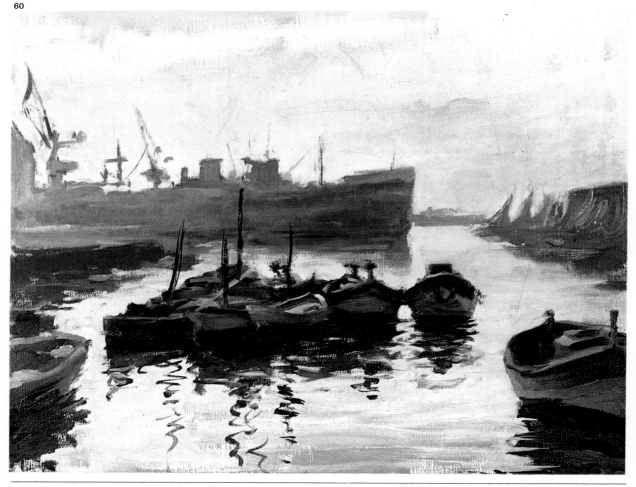

The Color of the Sky

"The sky was no longer a beautiful blue background, merely accompanying the figures —it changed into the deep vastness, where winds come and go freely, fogs accumulate and clouds deflate, and where the light leaves infinite hues with manifold tones and gradations."

A. Derain

Practically speaking, the same principle applies here as it did with the color of the sea: There is no one color of the sky; the sky does not have to be blue or gray. It's almost never just one single color. As always in painting, light corresponds to definite climatic conditions that determine the general tone of the painting, and this harmonic unity ought to exist between the sky and the water of a seascape. Therefore, it is very important to be able to ignore the details and "see" the overall effect of the sea's and the sky's fundamental and intimate relationship in accordance with the environment's color scheme. There should be a symbiosis between artist and nature.

I also want to mention that in many seascapes the sky is the true protagonist of the painting. The unusual variety of shapes and colors of the always changing clouds over the seascape horizon can be all that is needed for inspiration. This, accompanied by the lighter elements of the theme, a boat or a little strip of the sea, some rocks or hillocks, etc., can encourage us to create magnificent works of art.

The interpretation of cloud color in relation to sunrises and sunsets gives maximum possibilities for pictorial shaping

and for showing off nature's colors in her unequaled fantasies and chromatic effects. For this reason, this theme has always attracted painters and, as a result, famous works like Claude Monet's (1840-1926) *Impression: Sunrise,* which gave birth to the movement's name, testify to its importance. Make a few small studies of these motifs. Pay special attention to color and try to enrich your palette, extracting all the possible shades for general matching and harmonizing.

Fig. 61. A. Derain, *Reflections in the Water,* 1905. Annonciade Museum, Saint-Tropez, France. In a seascape, the sky and its colors can inspire the use of fantastic colors, in either warm or cool harmonies, that only the artist's feelings can determine.

61

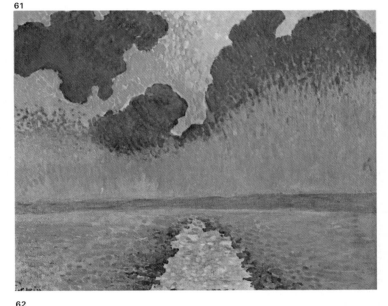

62

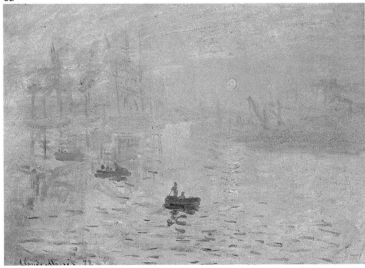

Fig. 62. C. Monet, *Impression: Sunrise,* 1872. Marmottan Museum, Paris.

The Color of the Sky

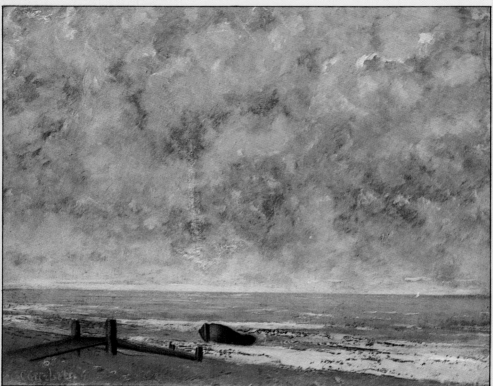

Gustave Courbet. *Paysage de mer par temps calme.* Musée des Beaux Arts, Caen.

The color of the sky is always lightest closest to the horizon. In the upper part of this painting, on a clear and light-filled day, blue tends to carmine or red, and is more ultramarine, while at the same time, when coming closer to the horizon, intensity is lost and the colors tend toward light yellow or greenish.

It isn't advisable to paint absolutely clear skies as a perfectly consistent gradation. It is better to create vibrations of light and color, mixing other blues or colors of slightly different hues that blend among themselves the idea of total uniformity.

Remember that the sky can be blue tend-ing toward yellowish, pinkish, violet-like. Frankly it can be orange, pink, yellow, green, or violet. In short, it can be gray in an infinite range of the tones of all different colors.

Clouds have mass and a definite shape; draw them paying special attention to their construction. Remember that normally they have a more illuminated area and another darker area, exactly the same as all other shapes; you must be careful not to fuse the areas or pass from one area to the other in an attempt to achieve form and authenticity. Also, avoid the "cottony" look.

Some Ideas about Composition

Although classical laws and norms do exist, the truth is that if we focus on the experimental evolution of painting from the impressionist period up until the present, we can almost assure you that no factor influences the creation of a painting more than composition.

Indeed, when we were discussing what inspires us to conceive a theme, and motivates our first creative impulse, we said that it was a question of untransferrable, personal feelings and intimate sensations. We also said that this is what makes art invaluable and unique. In the initial moments of creation, we intuitively know how we want the painting's shapes placed on the canvas. This is where we see the first and fundamental idea in the fine arts, through composition, so that every other factor that constitutes the work: the sketch, the color, the texture, etc., is subordinate to it.

It is important to have some general guidelines about this important aspect of painting, although excessive preoccupation with the study would hamper the artist's attempt to develop composition in a natural and logical way.

Composition means the process of combining a painting's (or any other work of art's) elements in order to achieve a visual unity with satisfactory characteristics. They say that the composition of a painting is correct if the elements that compose it, whether they're figures, apples, or simple, undefined shapes—provoke a sensation of harmony when contemplated as the integral parts of a two-dimensional whole.

Fig. 65. L. G. Gugliemi, *The River*. Art Institute of Chicago.

Fig. 66. C. Carrá, *Sails in the Port*. Art Institute of Chicago.

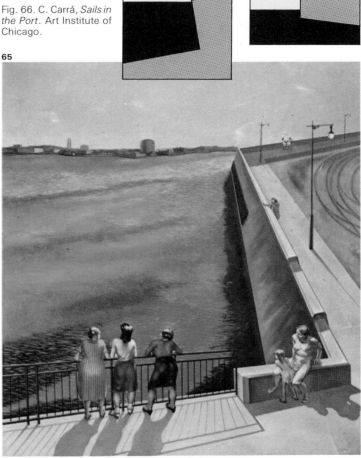

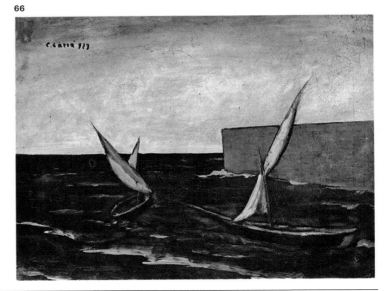

Some Ideas about Composition

- A satisfactory composition must have *balance*, which is determined by how the different masses complement each other.
- *Order and unity* of the whole. In art, the totality always represents much more than the sum of its parts.

Concepts still relevant today are summarized in the immortal words of Plato, the Greek philosopher of the fourth century B.C., who said, when his disciples asked him what composition was:

Fig. 67. A parallel, frontal composition can be very attractive if the elements are properly arranged.

Fig. 68. Superimposing the painting's elemental forms gives it depth and movement.

67

UNITY WITHIN VARIETY

VARIETY WITHIN UNITY

Putting these ideas into practice, we can specify the distribution of elements and shapes that compose the composition into three basic concepts: symmetry, asymmetry, and superimposition.

Symmetry is the distribution of a painting's elements on both sides of the central point in such a way that the parts correspond to one another.

Asymmetry is the free, intuitive distribution of a painting's elements balancing some parts with respect to others, with the intention of maintaining and achieving a unity within the whole.

Superimposition is the situating of various shapes, some in front of others, creating a series of successive planes or boundaries that should in principle obtain a certain unity.

Study the illustrations.

68

Superimposition of elements

69 **Symmetry** 70 **Asymmetry**

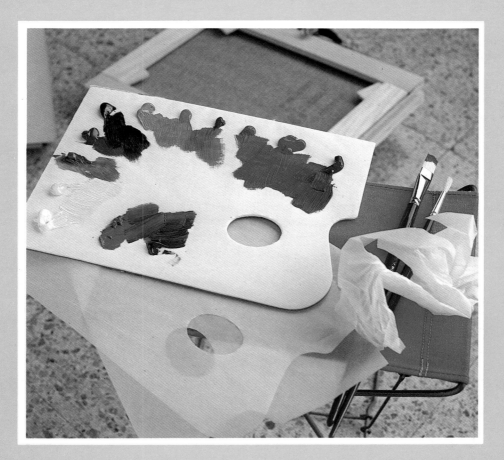

MATERIALS AND
CONCEPTS FOR
PAINTING SEASCAPES

Easels

The materials that are used for seascape and landscape painting are practically the same as the ones that are used for the other painting genres, oil as well as watercolor. Let's describe them according to their classification.

Basically there are two types of easels: the *country easel* for painting outdoors and the *workshop easel* for studio painting. The country easel consists essentially of a wooden tripod with folding articulation devices that make it easy to transport. In any case, it must meet the fol-lowing requirements: it must be solid but lightweight, high enough for painting standing up, have a mechanism for raising and lowering the painting, and have a mechanism on the upper part for holding the painting firmly in place.

Aluminum country easels, widely used these days for their convenience, have the advantage of being lightweight but this can also be a disadvantage, if they are too light.

The modern easel-box, the country easel best liked by the professional, inclines

Fig. 71. A metal country easel is especially recommended for watercolor painting.

Fig. 72. Folding easel-box for outdoor painting. A classic, practical model.

Figs. 73 to 75. Folding chairs with and without backs.

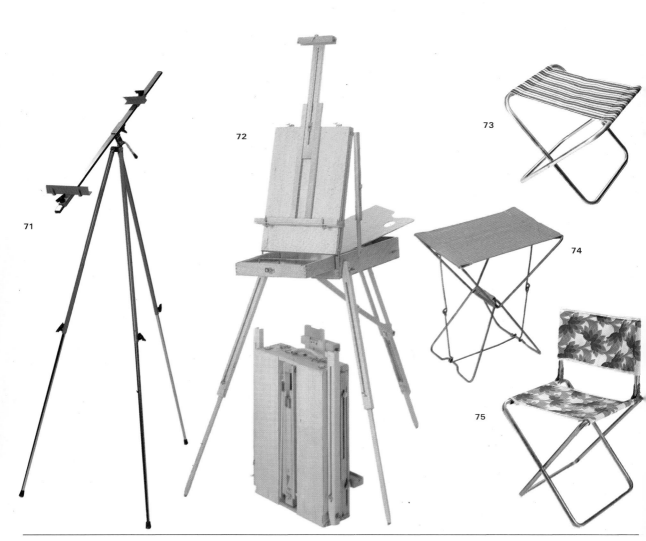

easily to avoid glare; it accommodates large canvases (24 × 36 inches or 30 × 40 inches, or size 30 or 40 on the international list of measurements); it can be raised and lowered, the legs can be folded, and the drawer that holds paints and brushes can, when left half open, be used as a ledge to rest the palette, freeing the hand.

Study the photographs here of the three most common country easels.

It is also useful to have a stool or chair for outdoor painting. Painting standing or sitting is a personal preference that doesn't affect the result or quality of the work, but, at times, because of the view selected, it is necessary to paint sitting down. For this I recommend an aluminum and canvas camping chair with a back. It is comfortable and lightweight. Always take it when you go out to work. The studio easel always has the common characteristic of the movable tray that permits the raising and lowering of the painting to its desired height and affords easy access to the tubes of paint that are being used. Study the photographs.

Fig. 76. Typical three-legged wooden stool with a seat that can be adjusted by a screw that turns on an axis.

Fig. 77. A metal chair with upholstered seat and a flexible back that can be adjusted for height.

Fig. 78. This is the most well-known studio easel, commonly used for oil painting with the added feature that it can be put in a vertical position for painting watercolors.

Fig. 79. Classic studio easel used for centuries.

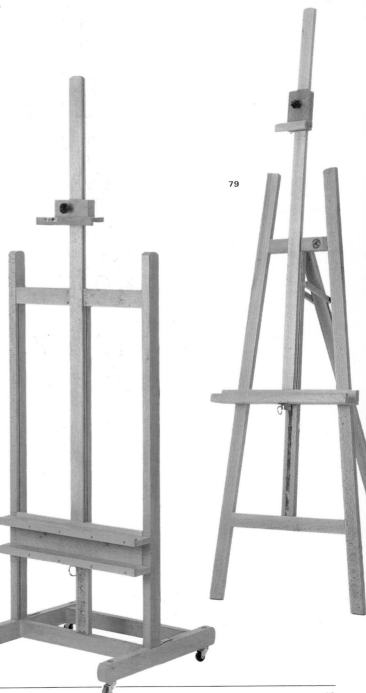

Palettes and Paintboxes

Palettes come in various styles. There are shaped wooden ones, plastic ones, and spongy paper ones in block form that have the advantage of having disposable sheets. But the classic rectangular wooden one is the most widely used. Especially for outdoor painting, there is no substitute for the basic paintbox or the carrying case with fitted palette.

This palette can be transported after use without being cleaned because of the way it fits into wooden strips that are grooved to hold it apart from the rest of the box. The grooves can also be used to hold a small painting in progress. Once the work is finished, you turn it over so the palette won't stain it. The paintbox comes in various sizes, generally standardized precisely for the transportation of standard-sized supports or cardboard and is divided into various zinc compartments for carrying all the equipment necessary for painting: tubes of paint, brushes, containers for turpentine, and rags. Study the illustration.

The purpose of the paintbox is to allow you to "take your workshop with you" —to the street, the country, the sea— so that we can even eliminate the easel, as the paintbox top inclines in such a way as to permit us to work freely by supporting it on our knees, or if we are sitting on the ground, on a boat or a rock.

Fig. 80. Classic oval wooden palette, not used as frequently as the rectangular one because it doesn't fit in the paintbox.

Fig. 81. Paper palette. It has the advantage of not having to be cleaned. After the sheet is used, it is torn off and thrown away.

80

81

82

83

84

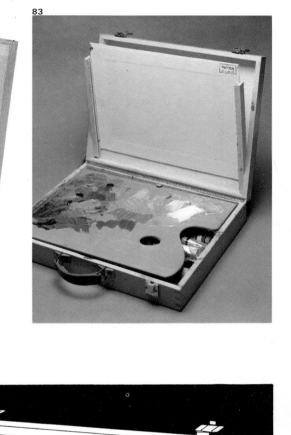

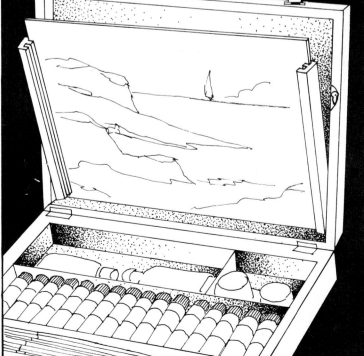

Figs. 82 to 84. Classic wooden paintboxes with metal compartments hold the equipment necessary for outdoor painting. The wooden strips inserted in the top of the box permit the work to be transported immediately after painting, while the paint is still soft. Standard sizes of canvases or cardboard are stored in the hollow on the top.

Color Chart for Painting in Oil

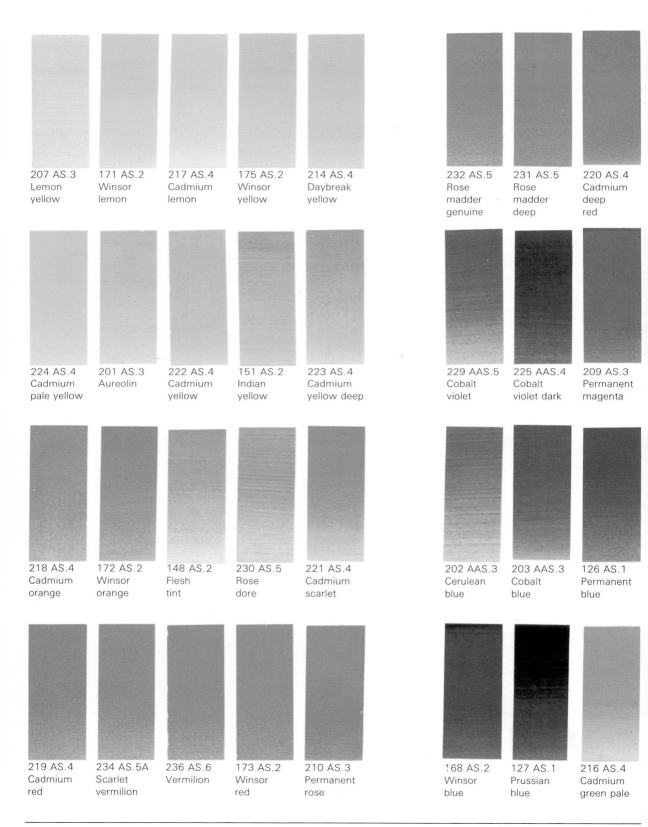

207 AS.3
Lemon
yellow

171 AS.2
Winsor
lemon

217 AS.4
Cadmium
lemon

175 AS.2
Winsor
yellow

214 AS.4
Daybreak
yellow

232 AS.5
Rose
madder
genuine

231 AS.5
Rose
madder
deep

220 AS.4
Cadmium
deep
red

224 AS.4
Cadmium
pale yellow

201 AS.3
Aureolin

222 AS.4
Cadmium
yellow

151 AS.2
Indian
yellow

223 AS.4
Cadmium
yellow deep

229 AAS.5
Cobalt
violet

225 AAS.4
Cobalt
violet dark

209 AS.3
Permanent
magenta

218 AS.4
Cadmium
orange

172 AS.2
Winsor
orange

148 AS.2
Flesh
tint

230 AS.5
Rose
dore

221 AS.4
Cadmium
scarlet

202 AAS.3
Cerulean
blue

203 AAS.3
Cobalt
blue

126 AS.1
Permanent
blue

219 AS.4
Cadmium
red

234 AS.5A
Scarlet
vermilion

236 AS.6
Vermilion

173 AS.2
Winsor
red

210 AS.3
Permanent
rose

168 AS.2
Winsor
blue

127 AS.1
Prussian
blue

216 AS.4
Cadmium
green pale

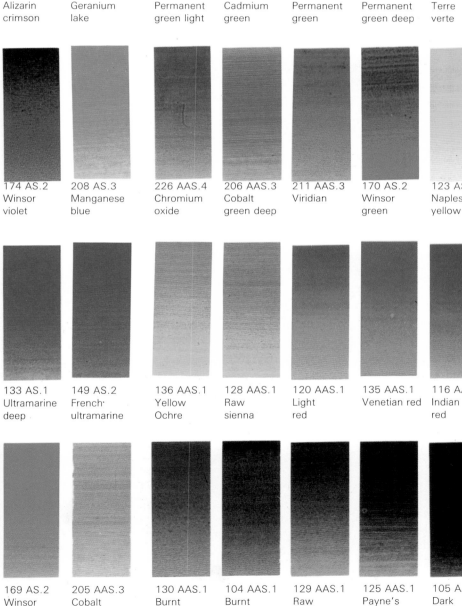

This color chart for oils is published courtesy of Winsor & Newton and contains 70 colors. The complete range can go up to one hundred and fifteen colors.

142 AS.2
Alizarin
crimson

146 AS.2
Geranium
lake

162 AS.2
Permanent
green light

215 AS.4
Cadmium
green

160 AS.2
Permanent
green

161 AS.2
Permanent
green deep

131 AAS.1
Terre
verte

174 AS.2
Winsor
violet

208 AS.3
Manganese
blue

226 AAS.4
Chromium
oxide

206 AAS.3
Cobalt
green deep

211 AAS.3
Viridian

170 AS.2
Winsor
green

123 AS.1
Naples
yellow

133 AS.1
Ultramarine
deep

149 AS.2
French·
ultramarine

136 AAS.1
Yellow
Ochre

128 AAS.1
Raw
sienna

120 AAS.1
Light
red

135 AAS.1
Venetian red

116 AAS.1
Indian
red

169 AS.2
Winsor
emerald

205 AAS.3
Cobalt
green

130 AAS.1
Burnt
sienna

104 AAS.1
Burnt
umber

129 AAS.1
Raw
umber

125 AAS.1
Payne's
gray

105 AAS.1
Dark
charcoal gray

Canvases

For oil painting you use cloth or canvas, cardboard, plywood, and also—for small studies and sketches—thick drawing paper. All these surfaces must be prepared with a thin white base made of paste scraps, called rabbitskin glue, and chalk or Spanish white.

The best canvases for oil painting are, of course, the pure linen ones, but blended ones, made of a mix of more or less equal parts of cotton and linen, are also used. We are including here the international list of standardized sizes for frames that all the manufacturers agree upon and that you will find in all art supply stores. Notice that the square measurements most currently used are indicated along with the new more oblong ones, which are called "seascape." This nomenclature of dimensions is arbitrary because a seascape can easily be painted in a figurative or landscape frame. The selection of the size and dimension is a personal one that depends mostly on the painting's composition and intrinsic theme.

85

F

L

S

Fig. 85. Study the comparative dimensions of universal sizes for figurative, landscape, seascape.

Fig. 86. Diverse surfaces currently used for oil painting. Linen, cotton, cardboard, plywood, Tablex, etc.

86

88

87

No.	PORTRAIT	LANDSCAPE	SEASCAPE
	INTERNATIONAL FRAME SIZES		
1	22/16	22 × 14	22 × 12
2	24/19	22 × 16	24 × 14
3	27/22	27 × 19	27 × 16
4	33/24	33 × 22	33 × 19
5	35/27	35 × 24	35 × 22
6	41/33	41 × 27	41 × 24
8	46/38	46 × 33	46 × 27
10	55/46	55 × 38	55 × 33
12	61/50	61 × 46	61 × 38
15	65/54	65 × 50	35 × 46
20	73/60	73 × 54	73 × 50
25	81/65	81 × 60	81 × 54
30	92/73	92 × 65	92 × 60
40	100/81	100 × 73	100 × 65
50	116/89	116 × 81	116 × 73
60	130/97	130 × 89	130 × 81
80	146/114	146 × 97	146 × 89
100	162/130	162 × 114	162 × 97
120	195/130	195 × 114	195 × 97
	50/50	100 × 100	80 × 40
	60/60	130 × 130	100 × 50
	80/80	150 × 150	130 × 60

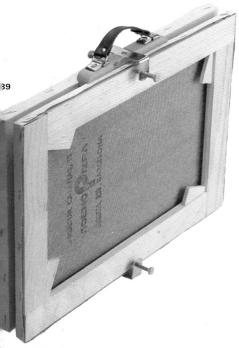

90

Fig. 88. All the canvases for painting sold in stores have a number on the back.

Fig. 89. A portable frame for carrying two canvases, designed so that, even when wet, the canvases will not stain each other.

Fig. 90. A pointed canvas separator, when placed in the four corners of the canvas, prevents them from staining each other.

Portable Frames

This is a simple and practical tool made in two pieces in order to carry painted canvases. The most up-to-date model is shown in the photograph. As you can see, it is necessary that both of the canvases are the same size to obtain the desired protection for the painted canvas.

Another System

This method of separating the two canvases, in order to transport a recently painted one, makes use of a type of two-pointed nail that is inserted on the four corners of the canvas to separate the two canvases.

Brushes and Palette Knives

Brushes

Horsehair brushes are the best for oil painting. They are bone colored, hard, and can withstand frequent washings. Fine-haired sable brushes, of a light brown color, can also be used for specific painting styles and in special cases, such as when painting a superimposed trace of a line—thin branches, blades of grass, the thin masts of ships, etc.—and if it's necessary to do it in an already finished area, the sable brush soaked with paint and a little turpentine, can paint over, scarcely mixing with the underneath color, thanks to the soft hair that doesn't splatter the recently painted surface.

The manufacturing of brushes is also standardized in three tip shapes: round, flat, and filbert or "cat's tongue." Each brush number determines the hair's thickness in even numbers from number 1 to number 24.

The choice of the type and number of the brushes depends on one's individual preferences. Nevertheless, see on the table the most current assortment for seascape painting.

After using them, the brushes should be carefully cleaned. For this purpose, use running water and ordinary soap.

It's useful to have some rags handy—preferably of nonacrylic fibers—to clean the brushes, erase some area on the painting, clean your hands, and also to clean the palette knife when the work is over.

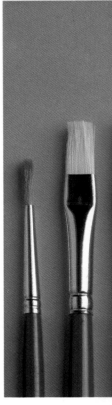

Fig. 91. Here you see three types of brushes used for painting in oil: round, flat, and filbert (or "cat's tongue").

Figs. 92 and 93. Don't forget to clean your brushes after using them.

Assortment of Brushes Currently Used for Seascape Painting

A round brush, sable hair, number 4.
Two flat brushes, horsehair, number 6.
Two round brushes, horsehair, number 8.
A filbert brush, horsehair, number 12.
Two flat brushes, horsehair, number 14.
A filbert brush, horsehair, number 16.
A flat brush, horsehair, number 20.
A flat brush, horsehair, number 22.

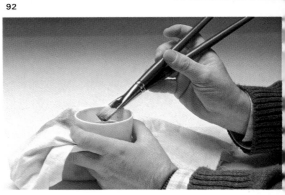

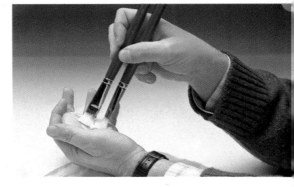

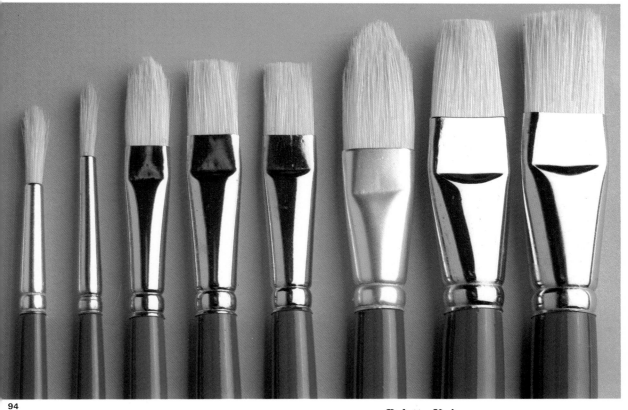

94

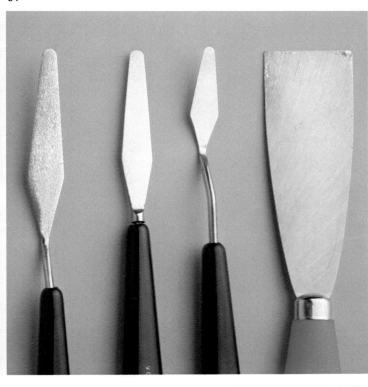

Palette Knives

Palette knives are very useful tools for oil painting. Made of flexible steel with wooden handles, they serve several purposes: they are used instead of brushes for painting all or specific parts of the canvas; they can take off recently applied paint from an area to be changed; and they can also be used to get rid of leftover paint on the palette when work is finished. The most up-to-date are the ones shaped like bricklayers' trowels, the knife-shaped ones, and the flat spatula or scraper whose steel is of a harder consistency than the others.

Fig. 94. These are the palette knives most commonly used by the professional artist when painting in oils.

Turpentine and Varnishes

Although there are various types and qualities, only two kinds of turpentine or "spirits" are commonly used in oil painting: oil of turpentine or refined turpentine and linseed oil.

The oil of turpentine gives a matte quality to colors, while linseed oil tends to make them shiny. When refined turpentine is used, the colors dry faster, and for this reason it is highly recommended for painting seascapes outdoors. A mixed solution of half refined turpentine and half linseed oil is also now being used. Both products are sold in small bottles so they can be carried in the paintbox.

Varnishes

There are two types of varnish: the varnish for touch-ups and a protective varnish, or final coat. Both are available in matte and glossy finishes.

The varnish for touch-ups is for touching up areas where the paint has been absorbed into layers underneath. When the touch-up varnish is applied, the colors equal out in their intensity and the paint recovers its normal shine. When working still-wet paint, sprays provide an invaluable service.

The protective or final coat of varnish is applied, as its name implies, when the painting is completed and dry. As a general rule, an oil painting is considered completely dry after one year, so a coat of varnish should be applied after that. We can also buy this varnish in a spray can, but in this case, a flat, wide brush should be used because it allows the varnish to penetrate all the crevices left by the various thicknesses of the paint.

Containers

Use two small containers for turpentine so that you can rest them on the edge of your palette by attaching a metal or plastic support stripsee the photograph, figure 96.

95

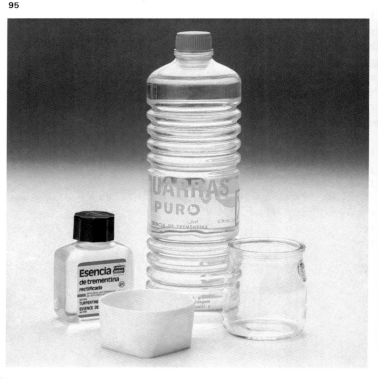

Fig. 95. Turpentine comes in small jars or large bottles, some holding up to one gallon.

Fig. 96. Containers for linseed oil and turpentine can be used while painting when clasped to the edge of the palette with a support strip.

96

For painting seascapes outdoors on sunny days it's advisable to use a beach umbrella, or a hat with a visor so you don't get sunstroke. The sunlight and the sea together create a dazzling glare on the white canvas that can spoil the tonal harmony and quality and result in negative effects.

A camera is also very useful. You can take a picture of your work at the opportune moment, when the light and surroundings best suit your needs, then later when you get home or back to the studio, you can "finish" the part you were working on. Naturally, the photograph must be in color.

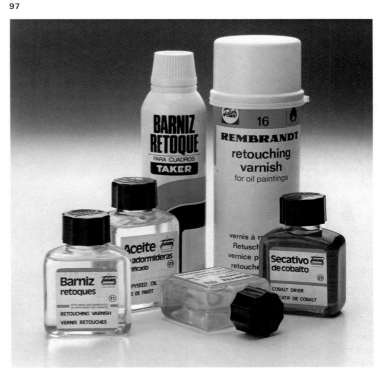

97

Fig. 97. Oils and varnishes are sold in glass containers of various sizes and also in aerosol spray cans.

98

Oily and Watery Paint

In order to keep a painting from cracking over time, it is necessary to paint the first layers with more turpentine than linseed oil. Oil paintings—especially when diluted with linseed oil—are oily; when diluted with turpentine, they are watery. A layer of oily paint takes longer to dry than a watery one. When a watery layer is painted over an oily one by mistake, the watery dries faster than the oily; when this last layer dries, the above layer contracts and splits the painting and the painting looks cracked. Paint oily over watery.

Watercolor Paper and Paints

The Paper

Watercolor paper is available in single sheets, which must be mounted on cardboard, or bound together in block form. Some of these sheets are called "deckled" when the edges have an irregular finish, which shows that the paper is handmade; others have a regular, perfect finish that means they have been machine cut. Watercolor paper is also glued against thick, resistant cardboard so that it does not have to be mounted on the drawing board. Study the photograph that shows some of the paper most used for watercolor in blocks with twenty or twenty-five sheets.

The Paintbox

Watercolor paints come in little pans that fit in round, square, or rectangular cases. Normally, the round pans contain dry watercolor paint, which is the most economical, and the square or rectangular pans contain the wet paint, which is what professionals use. Watercolor paint also comes in tubes. Study the photographs.

99

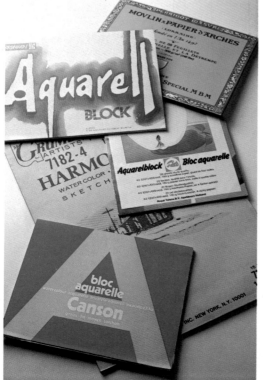

• A large paintbox of twenty-four colors in pans of wet paint. The color tray can be removed, making more space to mix paints; in the center tray you can see a mark (A in fig. 101) on the metal that holds the center ring underneath used to hold the palette with the thumb of the left hand. When you have finished painting, the color tray

100

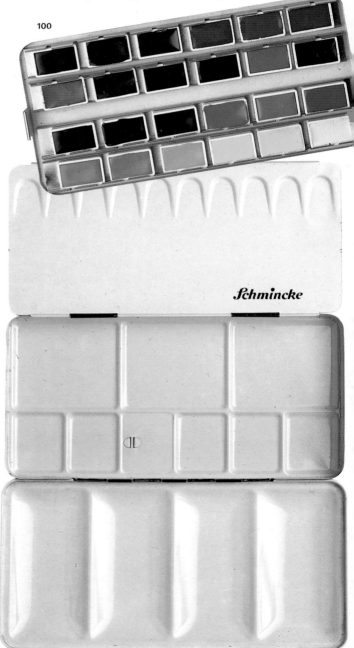

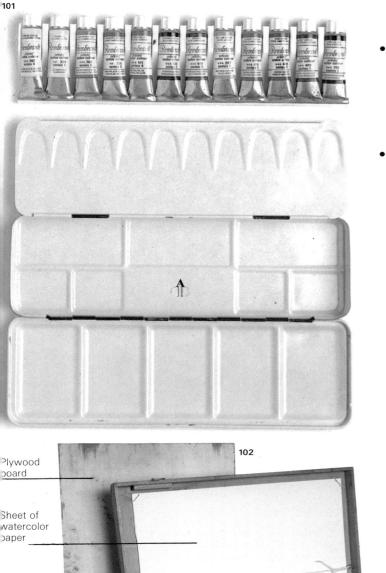

101

fits back into the box that can be folded into place and closed as one unit.

- A paintbox with twelve tubes of professional-quality water paint; when the tubes are taken out, the box converts into a palette, with the resulting hole for the thumb of the left hand that can be inserted through the interior to hold the box.

- A paintbox ideal for painting outside the studio. It was specially designed for the professional watercolor painter Ceferino Olivé and it measures 29½ inches × 9 inches (75 cm × 22 cm), permitting you to carry everything at once: the watercolor paper, a plywood board, a folding tripod-style easel, a plastic container for the water, colors, palette, brushes, sponge, etc.

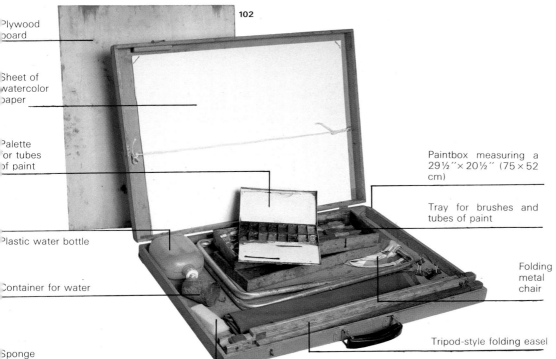

102

Plywood board

Sheet of watercolor paper

Palette for tubes of paint

Plastic water bottle

Container for water

Sponge

Paintbox measuring a 29½″ × 20½″ (75 × 52 cm)

Tray for brushes and tubes of paint

Folding metal chair

Tripod-style folding easel

Watercolor Brushes

The most widely used and highly recommended watercolor brushes are the sable and ox-hair ones. The photograph at right shows a minimum assortment of necessary brushes: three sable-hair brushes, numbers 8, 12, and 14, and a number 24 ox-hair brush.

Three complementary and useful tools that go with the above-mentioned brushes are a spatula-shaped brush, a roller sponge, and a small natural sponge. These are necessary for working on backgrounds and wide gradated areas; the sponge is used for absorbing water or color when necessary.

Coming back to the subject of watercolor paper, let me remind you that it is necessary to mount the paper on the drawing board in order to avoid the wrinkles produced by wetness. Study the photographs and the text.

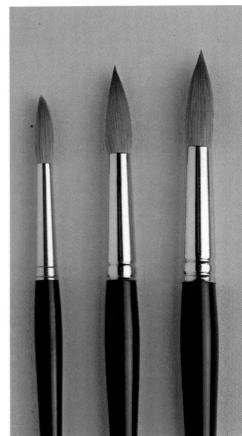

103

Figs. 103 and 104. Sable-hair brushes numbers 8, 12, and 14; a number 24 ox-hair brush; and three complementary tools: a spatula-shaped brush, a roller sponge, and a small natural sponge. These three tools are necessary for working on backgrounds and wide gradated areas. The sponge, which should be natural, is used for absorbing water or color when necessary.

Fig. 105. When you are painting a watercolor with Chinese ink and water, or with watercolor when the paper isn't thick enough, it's necessary to wet it, mount it, and stretch it in order to avoid wrinkling and rippling. To stretch the paper, first hold it under water with both hands wetting it for two minutes.

Fig. 106. Immediately stretch the paper against a wooden board so it will expand more easily.

105

106

Fig. 107. Next, tape down the edges of the paper.

Fig. 108. Repeat the operation on all the edges until the paper is framed and taped, leaving it horizontal for four or five hours until totally dry. Then paint on the stretched, flat surface without worrying about wrinkling or warping the paper.

Fig. 109. Here are several appropriate containers for water.

107

108

104

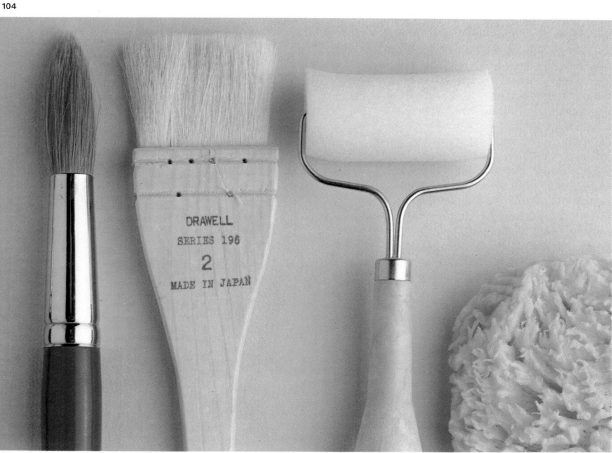

109

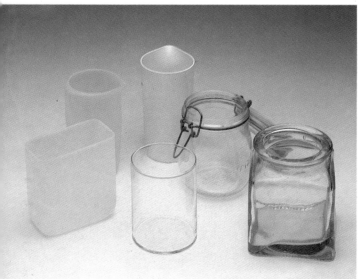

Water, Lots of Water

The only liquid necessary for watercolor painting is clean tap water. Shown here are some appropriate containers for water: glass for working in the studio and plastic, which is more resistant to breakage, for the country. In any case, the jars should have wide mouths and hold a minimum of a pint of water.

Perspective

Perspective is the science of representing shapes, objects, and views three-dimensionally, just the way we see them, over a flat surface.

We use perspective to make the shapes represented in our paintings and drawings seem to have three dimensions and, in general, to suggest proximity or distance. In other words, to create the sensation of space.

In the distance, the sky seems to join the land in one single line: the horizon. In the sea, the horizon really converts itself into a continuous line. The horizon is constant and permanently situated in place, even though its view may be obstructed. If all landscape or seascape forms became transparent, we would still be able to see the horizon. This line is always at eye level and is the first concept or element to be considered when drawing in perspective.

If we situate ourselves on the beach, standing facing the sea, without raising or lowering our heads or varying our gaze, the water and the sky will meet just at eye level, in other words, on the horizon. But if we lower our heads or lie down in the sand, always facing front, we will see how the horizon's line lowers itself with us; the visible strip of water is narrower, but the horizon's line continues to be eye level. Let's go high up into the building next to the beach or the hill along its edge; the horizon goes up with us and the strip of the sea widens considerably. Study the examples.

110

111

112

Figs. 110 to 112. The horizon is always there. It goes up and down with us because it is always at eye level. But remember, although we don't always see it the way we do at the beach, we must always keep it in mind when drawing and painting.

Parallel Perspective and One Vanishing Point

When we situate ourselves in front of the shapes and forms we want to represent in such a way that the lines or edges of depth run perpendicular to the horizon line, we draw in parallel perspective —that is, with one *vanishing point*. Notice how the adjoining illustration's railroad tracks that cross the plain converge in one point, precisely at the horizon, where we lose sight of them; this point is called the vanishing point.

Oblique Perspective or Two Vanishing Points

When we situate ourselves in front of the shapes in such a way that the lines and edges of depth do not run perpendicular to the horizon, we draw in oblique perspective with two vanishing points. In this case, there are two vanishing points—the places where all the parallel lines or edges of depth meet—but both of them are always on the horizon. Look at the example. As we already specified, we cannot correctly represent the shapes that we see without having a knowledge of perspective.

113

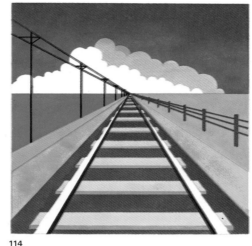

114

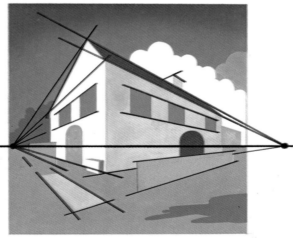

115

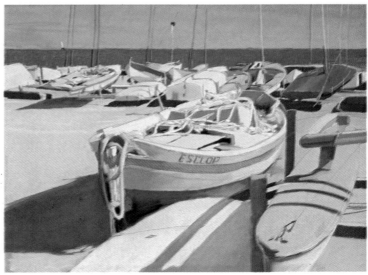

Fig. 113. **Parallel Perspective.**

Fig. 114. **Oblique Perspective.**

Fig. 115. S.G. Olmedo. *Beach at Sitges.* The correct application here of parallel perspective is what gives the painting such a great feeling of depth.

Color Theory

"The fact is that in painting, as in other arts, there isn't one particular method compact enough to be able to put it into a formula.... I think I know before the scientists that the contrast of yellow and blue produces violet shades, but even when you know this, you ignore it. In painting there exist many inexplicable essential things. You go to nature full of theories and end up tossing them on the ground."

Pierre-Auguste Renoir

Okay, fine... but Renoir (1841-1919) and all the impressionist masters knew the laws of color very well and the ways in which colors react outdoors. They also knew how to capture them in harmonious and convincing sensations in their paintings.

Nature "paints" with colors of light. Sir Issac Newton (1642-1727) reproduced the rainbow phenomenon by intercepting a ray of light in the dark with a crystal prism. He was able to break up the white light into six colors on the spectrum. Nineteenth-century physicist Thomas Young did the opposite. Investigating colors with lanterns, he was able to recompose them into white light. And

furthermore, he arrived at the important conclusion that all the colors of the spectrum could be reduced to three primary colors of light: green, red, and dark blue. Mixing these three colors into pairs, Young found the three secondary colors of light: cyan blue, magenta, and yellow. Everything that is illuminated by solar light simultaneously receives the three basic and three secondary colors of light.

Fig. 116. Reconstructing light. Projecting three beams of light through three filters with the primary colors of light (green, red, and dark blue) will reconstruct white light. Projecting the primary light colors in pairs, you obtain the three secondary colors of light: yellow, cyan blue, and magenta.

Fig. 117. Dispersing light. When a ray of light is intercepted by a triangular crystal prism, the light breaks down into the colors of the spectrum, producing the same phenomenon as the rainbow.

Artists, however, paint with pigments, not with light. The primary pigment colors are the secondary colors of light and vice versa.

Primary Pigment Colors:
Yellow
Cyan blue[1]
Magenta

Secondary Pigment Colors:
Red
Green
Dark Blue

Pigments absorb some colors of light and reflect others back to our eyes. The more pigments are there, the more colors they absorb, and the darker the resulting color will be. If we mix red and green, for example, we get a darker color: brown. If we mix all our primary pigment colors together, we get black. Physicists call this *subtractive synthesis*. Colors of light, on the other hand, mix by additive synthesis. Adding a beam of red light to a beam of green light increases the quantity of light and thus logically yields a brighter color —in this case, yellow.

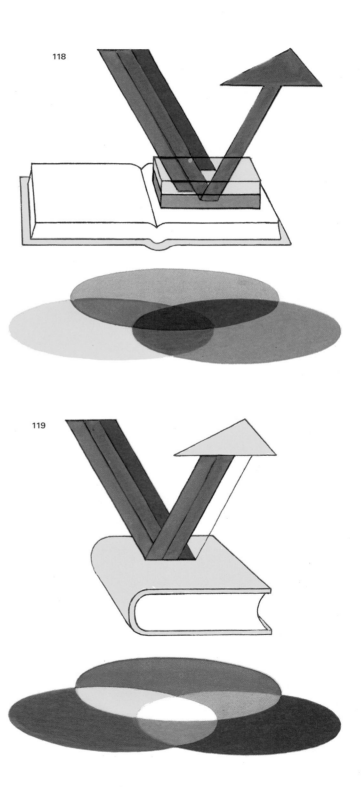

Fig. 118. Subtractive synthesis. In order to paint or print green, a secondary pigment color, we mix yellow and cyan blue. The yellow pigment absorbs the dark blue light, and the cyan blue pigment absorbs the magenta light; the only color they both reflect back to our eyes is green.

Fig. 119. Additive synthesis. When an object looks yellow to us, which is a secondary light color, its surface absorbs dark blue light and reflects red and green light back to our eyes. These colors of light mix to create the yellow light we see.

1. Cyan blue is not on the oil or watercolor chart; it belongs to graphic arts and color photography and it has been adopted by all the up-to-date treatments on color theory. It corresponds to a neutral blue, very similar to Prussian blue mixed with a little bit of white.

Complementary Colors

Now look at the color wheel below. Beginning with the three primaries (P), an even mixture of parts gives us the three secondary colors (S), which mixed with the primaries, give us six more *tertiary* colors (T). The color wheel shows us what colors are complementary to each other and considers them in pairs. Here is what we see:

Yellow is complementary to dark blue; cyan blue is complementary to red; and magenta is complementary to green (and vice versa).

It is essential for you to understand the complementary color theory for any painting technique. It allows you to create color contrast in a deliberate way by juxtaposing any of the pairs: a green next to a red will always offer an extraordinary contrast, for example. In unilluminated areas or in shadowed areas, the complementary color of the illuminated shape that produces the shadow is always used to obtain harmonious and appropriate grays in whatever general or specific blend or match that we want to impart on our work.

All of this justifies the knowledge of color theory and leads us to the following conclusions for applying it:

The similarity between light colors and pigment colors permits the artist to imitate light's effects in the illumination of his or her forms, and consequently to reproduce nature's colors with a certain degree of accuracy. Adhering to the theories of light and color, the artist can obtain all the colors that exist in nature by using only the three primaries: cyan blue, magenta, and yellow.

120

121

Fig. 120. The juxtaposition of two complementary colors is used by many artists to enhance maximum contrast.

Fig. 121. The chromatic circle of pigment colors showing the *primary* colors (P) which when mixed among themselves in pairs, provide the three *secondary* colors (S), which when mixed together in pairs, gives us six more colors, the *tertiary* colors: light green, orange, violet, carmine, emerald green, and ultramarine blue.

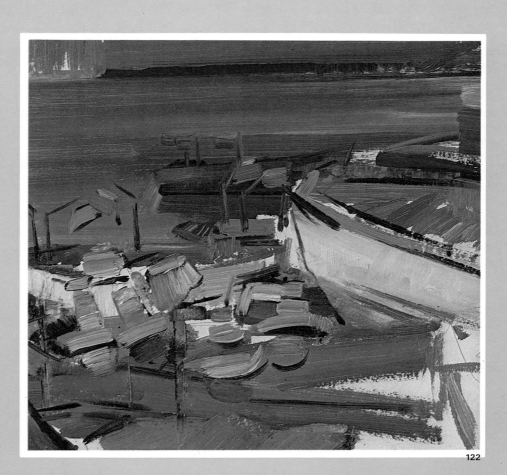

122

THE ACTUAL
—PAINTING—
OF SEASCAPES

The Practical Process of Painting

I think it has been sufficiently demonstrated on the previous pages that the act of painting is an absolutely personal and subjective endeavor. In all honesty, I must tell you that there are no methods or formulas for painting seascapes or any other painting genre. If there are any, and anyone uses them, the results achieved can at best be considered technically good. If we look at true works of art, we see that it is impossible to achieve anything creative merely by using formulas.

Naturally, this doesn't mean that we can't speak about rules and general procedures, especially of a technical nature, that are valid for everyone and that can facilitate our understanding of concepts and styles of painting. This part of our discussion demonstrates how to paint a seascape in a specific way; but at the same time we will consider the composition, sketch, harmony, illumi-
123

nation, etc, in an open minded way, paying attention only to the fundamentals, with the intention of leaving a path open to all possibilities of expression. There are questions that, as they have been discussed, are very general and enter into all work processes—for example, how to connect sky and sea, the sketching of ships, reflections, etc.—so that it will be necessary to adapt ourselves to a particular way of seeing and sensing the subject. Pay full attention to what follows. I have tried to analyze only the truly fundamental elements of each particular painting.

Fig. 123. F. Crespo, *Old Boat*. Private collection.

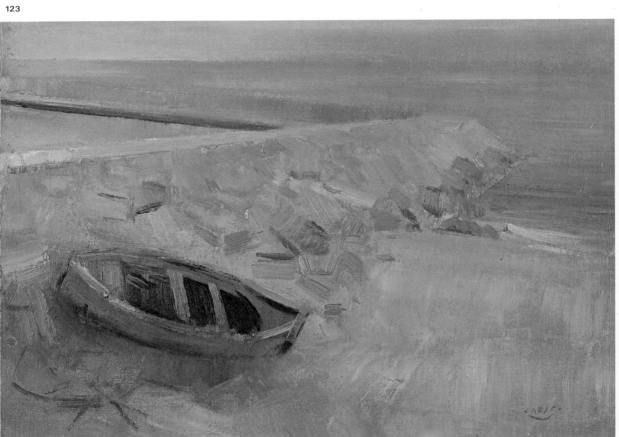

To Paint Outdoors or in the Studio?

Let's stop for a minute to ask an age-old question: where should we paint nature themes such as landscapes and seascapes? Directly in front of them or in the studio?

Well, in principle, for our needs, it might be more logical to paint all of the painting outdoors. This question can be applied to all themes. Should a figure painting or a still life composition be painted from a live model or a set-up? The ultimate goal is to achieve the painting, this "flat surface covered with colors joined together in a particular way."

And there is no doubt that it is a good idea to make studies and sketches directly in front of nature. Apart from this, referring as we said to the painting, nothing can be assured: the saying goes "every little master has his little book..."

I think it is a good idea to take the middle ground; begin the painting outdoors during one, two, or three sessions,

124

whatever is necessary, and finish it in the studio using previous drawings, color sketches, etc., to jog the memory and evoke the peace and necessary reflection to resolve the work according to our first concept. When a work is well done, nobody cares and nobody asks where it was done or how long it took to do it.

Fig. 124. F. Crespo, *Houses in Alcanar*. Private collection. These two small paintings, 12 inches × 18 inches (30 × 45 cm) were done outdoors in one session. Maybe because their size made it possible to maintain the first impression, it wasn't necessary to add a single brushstroke in the studio.

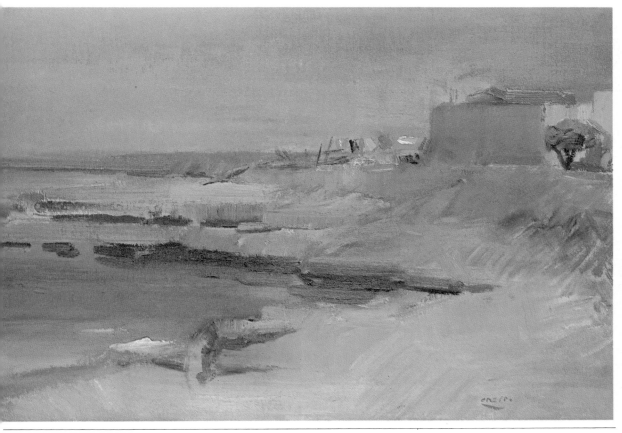

Plein Air and Colors in Tubes

In the beginning of the nineteenth century, painting was done exclusively in the studio. Systematically, painters used the formulas they inherited from the past, "technical recipes" that often made art a question of pure craft or a job well done.

But toward the middle of the century, Jean-Baptiste-Camille Corot (1796-1875), who did many outdoor studies in Italy, established himself as the defender of *plein air*, a term that the artists and critics used to distinguish the work of those painters who were beginning to paint landscapes in the open air, right next to nature.

Plein air was born in the Fontainebleau forests, the place where the young Parisian painters flocked to capture the beauty of nature. Besides Corot, Théodore Rousseau (1812-1867) and Jean-Francoise Millet (1814-1875) painted in Fontainebleau, where they established themselves in a little town called Barbizon. At the same time, painters of other nationalities integrated themselves into the group of artists who were painting directly before the natural setting, motifs or "impressions," in place of their predecessors' themes. And this is how the famous Barbizon school was born.

One of the biggest factors responsible for the practice of outdoor painting was the development of zinc tubes for the packaging of primary colors. These appeared on the market between 1850 and 1860. Naturally, at first, there were doubts with regard to the new paint's qualities, but finally, the technical advances in the industry allowed the manufacturers to obtain a consistent quality. Furthermore, these manufacturers were able to offer artists a much wider range of colors with a shine and richness that the old masters never dreamed of. Late in his life, Renoir said: "Paint in tubes permits us to paint outdoors. Without these colors in tubes Cézanne, Monet, Pissarro, Sisley... wouldn't have existed... nor would what the journalists call impressionism."

125

Fig. 125. E. Manet, *Monet in His Floating Studio*. 1874. Bayerische Staatsgenial Collection, Münich.

Interpretation

It is said that Cézanne's good friend Pierre Bonnard (1867-1947), struggled all his life to represent motifs as he saw them, in one single impression. In reality, many artists struggled to achieve this; Manet, Monet, Renoir, and many still do. Bonnard described the problem by saying that in principle, the painting is "one idea." This idea is realized in front of a model or a subject, but even long before you have it in front of you, you have worked it out in your mind, imagining it with other colors, other contrasts, a different harmony, and even different shapes. But the initial idea is sometimes weakened by the presence of the real subject, which unfortunately distracts and dominates the painter. When this happens, the artist is no longer painting his or her painting.

Claude Monet was terribly afraid that his subject would overwhelm him: he knew

126

that he would be lost if he spent more than fifteen minutes guiding himself by what he saw.

Bonnard said the following: "I tried to paint the roses in front of me, interpreting them in my own way, but I was carried away by details... and I realized that I was let down, that I wasn't going anywhere; that I had lost my way; I couldn't recover my first impulse, the vision that had dazzled me, my point of departure. "A model's presence, as far as subject goes, is a disturbance to the artist while he is painting. A model's presence while working on a painting is a temptation to the artist; the artist runs the risk of getting carried away by what he sees directly in front of him, forgetting his first impulse... and he ends up accepting the accident, he paints the details in front of him, which, in the beginning had no interest for him."

Fig. 126. C. Monet, *Sailboat in Argenteuil*. 1873. Norton Simon Collection (Photo SKIRA). A realist painter like Monet was afraid that the subject matter, painted outdoors, would dominate him and prevent him from accomplishing what he wanted. It is clear from his works that he knew how to overcome this fear and was able to execute his initial idea with overall unity.

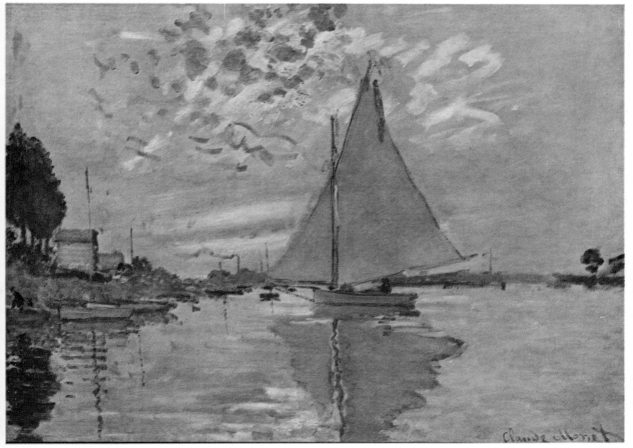

To Construct Is Absolutely Necessary

These days, many painters directly "attack" the painting without drawing it first, constructing with color by contrasts and different tones. This doesn't mean that they don't consider the drawing, because the layout and correct position of all of the shapes on the surface of the canvas, in short, their construction, must be adequate and correct in every case. We say that those who work like this also draw—only in another way. The drawing always exists!

Of course, in order to create paintings by applying color directly, one must have a great deal of knowledge of technique, which can only be obtained with a great deal of study and practice.

We have seen the importance a good sketch has on the visual arts. Of course, in seascape painting it is absolutely necessary to begin with a general structure of the whole painting, arranging the shapes or principal elements of the composition in an orderly fashion. The details can be worked out later. We're going to make our painting on a number 10 canvas.

Imagine representing an aspect of the Barcelona port on a bright spring day: Sketch a foreground of vegetation, consisting of a vaporous and undefined mass of wild plants and some cactus that give an exotic effect; a background determined by the expanse of the sea, interrupted by a horizontal strip in the distance of piers and docks. The outstanding characteristic is the elevated line of the horizon, which gives the composition its great depth.

There are two ways to draw when beginning a painting: use a thin or medium charcoal—which should be sprayed or atomized with a fixative when finished, the kind sold at art supply stores—or use a brush, with a dark or neutral color, diluted with enough oil of turpentine or turpentine.

In this case, we move on to the second procedure. With a round number 6 or number 8 brush and whatever color, Prussian blue, for example, very wet with oil of turpentine, we carefully compose the principal shapes of the painting. Pay attention:

Phase One

First we find the horizon, according to the point of view we have chosen. Next, we mark the horizontal strip of docks in the exact place they will appear in the painting. We now indicate lightly the two areas of mass that comprise the cactus and the plants in the foreground, being careful, above all, that they remain as proportional as possible to the reality that we are intending to represent.

We draw the elliptical shapes of the cactus, paying special attention to their direction because that's what gives them body. We do the same with these long, slender leaves in the foreground. At the same time, we define the principal dark areas of the cactus as well as those of the grass.

27

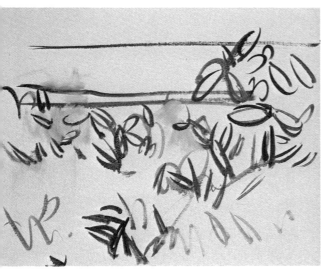

Figs. 127 to 129. A simple drawing to determine the painting's composition. With a flat horsehair brush, we begin to indicate the principal dark areas. Be careful of the brushstrokes angles.

128

29

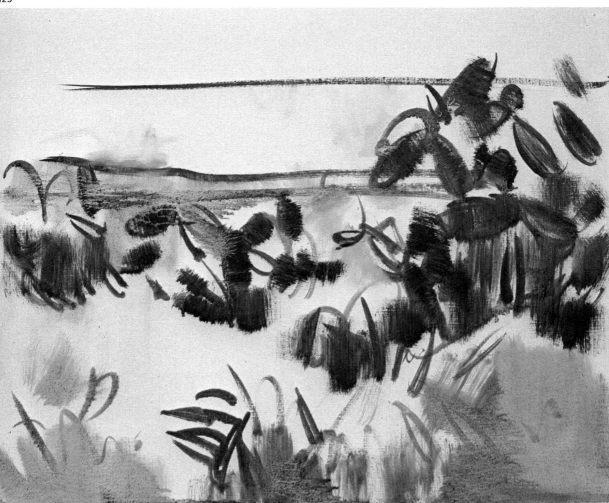

The "Stain" on the Canvas: the Most Important Step

Phase Two

By *stain* we professionals mean the first phase of the painting where the work's harmony is determined and the principal parts of the composition are structured in such a way that the entire surface of the canvas is covered, leaving out the details. This is usually done in one session. Before actually getting down to work, we should conceive the tone or overall harmony in our seascape. We should decide if bright lively colors will dominate or grays, more or less cool or warm. Naturally, this selection will depend on our vision of the outdoors, which we select. Simply stated: we decide if we are going to represent or interpret our subject on a radiant sunlit day or a misty cloudy one.

So, we have decided to "stain" the canvas in one session.

THESE ARE THE COLORS

As we decided , for a brightly lit setting in broad sunlight, the brush must correspond. Here's what we see: cadmium yellow medium, yellow ochre, cadmium red light, burnt sienna, dark carmine, permanent green, emerald green, cobalt blue, Prussian blue, black, and white.

THESE ARE THE BRUSHES

We will use four horsehair brushes and one spatula-style horsehair brush to fill in the backgrounds. For fine lines and little details, we'll use a sable-hair brush.

A horsehair brush, number	6
A horsehair brush, number	8
A horsehair brush, number	12
A horsehair brush, number	14
A horsehair flat brush, number	12
A sable brush, number	4

130

131

132

 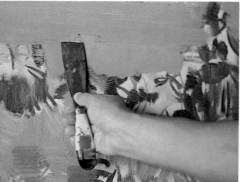

Figs. 130 to 132. With the same flat brush that we used before, we "stain" the sky, the sea, and the green foreground. We'll use the flat spatula or scraper to give verticality to the violet-like area of the sea, and with a number 14 flat brush we'll mark the strip of docks that divides the sea's surface.

33

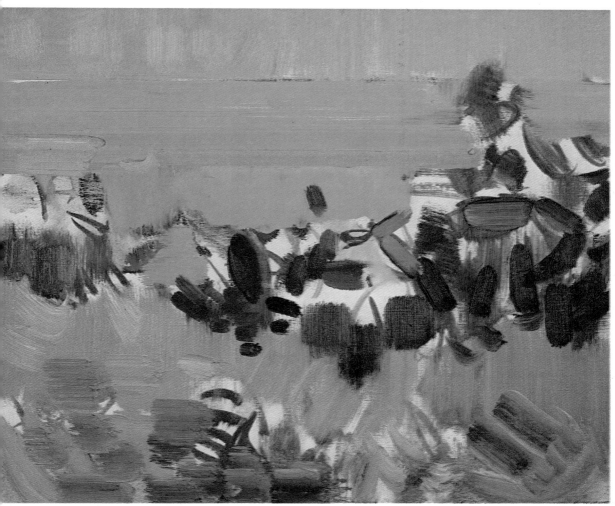

Fig. 133. The greens in the foreground are very complementary, in many distinct tones, and the grays are more or less violetlike or pinkish in the sky and sea. Notice that the dark areas, in their different warm and cool tones, are grouped together in the center of the composition.

134

Illumination... but, Above All, Harmony

By *illumination* we mean the gradations of tone from light to dark that can be observed in any solid form or object when it is lit. Another definition of the concept of "illumination" could be described as the relationship the artist establishes between the different tones or degrees of lightness and darkness in a drawing or painting.

By illuminating with color we add three-dimensionality to our drawing. We are constructing while at the same time giving richness of color to our composition and, in a word, painting for real. But these illuminations or the tones that correspond to these illuminations must be intimately related and connected.

Notice that already in the second or stain phase of creating the painting all the tones that I have used are subordinated to the overall tone of the work without betraying my personal vision of nature. Let's remember again the ordered and coherent sense of placing color on the canvas's flat surface—that which Maurice Denis said and many artists and art enthusiasts later corroborated. Because, although absolutely everything in art can be put in doubt, it is certain that many great paintings support the idea of the importance of illumination.

Phase Three

Keeping this concept in mind, let's illuminate our waiting seascape, as far as the lights, mediums, and darks, which will correspond to the maximum light, medium illumination, and shadow.

Here, in the actual painting, we will see the importance of knowing color theory: warms and cools, pure colors, grays; primaries, secondaries, complementaries. As a general rule, the complementary color of the colors that we have given to a specific shape or form, enters into its shadow's colors. So, in this case, we will find the cactus's shadow in the violetlike blue, complementary to the greenish-yellow that we used to stain the areas of light, in different tones and intensities. The same thing happens with the gray shadows of those little buildings on the·

docks in the background; we refine our initial stain with a warm dark gray that complements the lit area of the roofs and the ground's surface, also in gray, tending toward a rosy color.

As for the foreground, let's contrast it with the tone of the cactus's shape and with the docks and the sea's surface. The warm reddish colors enter and dominate the complementary blues and greens at the same time the bright mass does, rich in yellow tones.

Let's illuminate the color of the sea, in this case, bright bluish-gray tending toward warm, in a progressive gradation that practically merges with the sky, also with the progressively fine yellowish and orangeish tones, which, strictly speaking, are complementary to the coloration we have given to the sea's surface. We will use thinner brushes than we used for the stain, number 6 and number 8. You already know that there are infinite chromatic possibilities in regard to the harmony and general tone of the work.

136

135

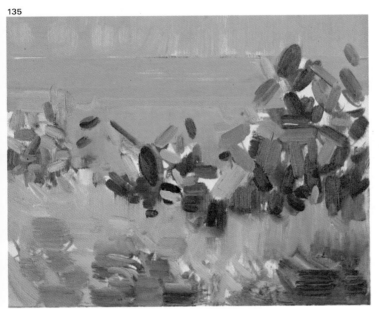

137

138

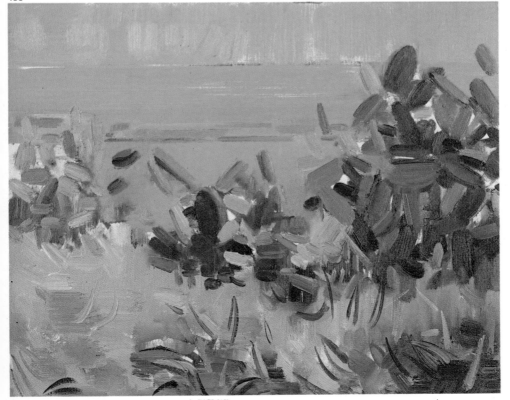

Figs. 135 to 137. With number 6 and number 8 brushes we illuminate the cactus with different tones and intensities and continue constructing, without details, the gray buildings on the dock. With a round number 14 brush we will draw in fine lines that make up the leaves or stems in the foreground. Notice how the fingers are useful for softening those areas that might otherwise be hard.

Fig. 138. This is the painting as it stands after phase three. It is now ready for the final phase.

Drawing with a Brush

All forms have a concrete structure or a principal characteristic with respect to their constitution that relates to the basic geometric shapes from which they derive. Don't forget this when it comes time to paint, as you will understand very well that form and color, that is, drawing and painting, form an indivisible whole.

I want to call your attention to this now, although I'm sure you have not forgotten: Indeed, with a brush we can draw and when we illuminate we are constructing a form with color, giving the appropriate direction and intention to the brushstroke. This is important because it gives greater variety and greater artistic richness to the final painting, avoiding the monotony in the process, which is dangerous to the finished work. Notice how in our seascape the brushstroke follows a logical direction that determines the form's true nature: direct, wide, and horizontal on the sea's surface; vertical predominance in the celes-tial vault; horizontal, vertical, or slanted in the cactus leaves that make up the cactus's complex form in the buildings on the dock in the background. In short, I advise you to remember these concepts in your future works.

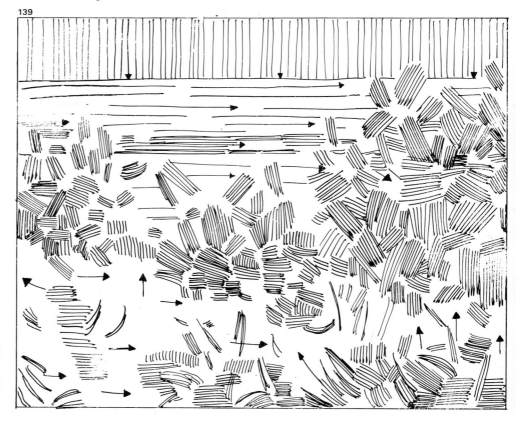

Fig. 139. Sketch of the brushstrokes that correspond to the natural constitution of the shapes or elements that enter into the painting.

The Final Step

magine how many ways there are to interpret and paint this theme or motif that at some moment has caught our attention! Really, no matter how much has already been done in painting, the range of color possibilities is so wide that nothing can prevent us from creating a personal and unique work. But remember, that in a work of quality, nothing just exists or is achieved by chance. Inspiration isn't worth anything without knowledge of technique.

Now we must finish the painting, but the truth is, this time I have held back because I want to adhere to the principles discussed throughout this book.

Indeed, up until now, we have seen a process for the creation of a seascape painted from nature where I think the most important things have already been said. But I do want to give you the opportunity to "finish" it... even if it means just using your imagination. Look at the square at the bottom of the page —it should also be the last sentence of our book. It means that you yourself have to figure out how to execute your final brushstrokes. Understand that this problem presents itself every time you create a painting, and that a good part of the work is found precisely in the way you finally resolve a correct layout.

Fig. 140. Imagine your own painting here.

140

**Put yourself
in your paintings**

Watch Out for Reflections

One of the most characteristic aspects of seascape painting—and, in general, all subjects that contain surfaces of water like lakes, rivers, and so on—is that the reflective surface acts as a "magic mirror," inverting forms and colors. Sometimes the reflection is tranquil and well defined; sometimes it is tremulous and in motion, adding a new dimension to these shapes. Reflected shapes also appear to us to have slightly different colors.

It brings up a problem that is easy to resolve. An object that rests on a mirror reflects itself upside down— in other words, inverts. Let's suppose we place a brick on a mirror. When we extend downward the vertical edges that determine the brick's height in order to obtain its top corners reflected in the mirror we find that these reflected corners maintain perspective in the same direction as those of the real brick. In other words, they are going to stop at the same vanishing points. But if we lift any object above the mirror, the reflection appears to sink below the surface at equal distance. At any rate, the principle is always the same: the distance between a point and a reflecting surface will always be the same as the distance between this surface and the reflected point. Study the adjoining illustration.

141

142

143

Figs. 141 and 142. It's very easy to understand how to resolve the problem of reflections in a painting. Notice that in the second example, the inverted shape is not exactly the same as the one that the reflection produces.

Fig. 143. V. van Gogh, *Starry Night Over the Rhone*, 1888. Private collection, Arles.

144

THE WAY
——THE——
MASTERS WORK

Teresa Llácer

145

Fig. 146. T. Llácer, *Guell Park*.

This is Teresa Llácer

Teresa Llácer has been exhibiting regularly in Barcelona since 1971. Her works are in the Montecatini-Italia Museum, in the Modern Art Museum of Barcelona, and in the collection of the Barcelona City Council. Presently she is a Professor of Art in the Fine Arts department of the University of Barcelona.

146

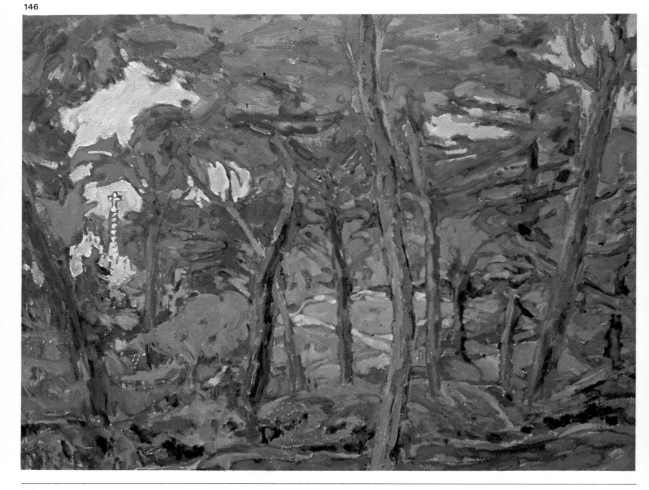

Some Paintings by Teresa Llácer

147

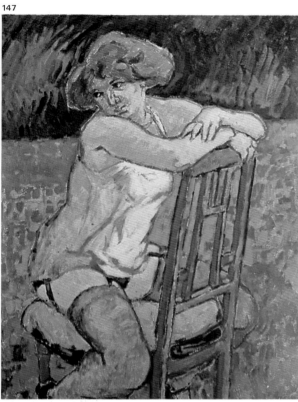

148

149

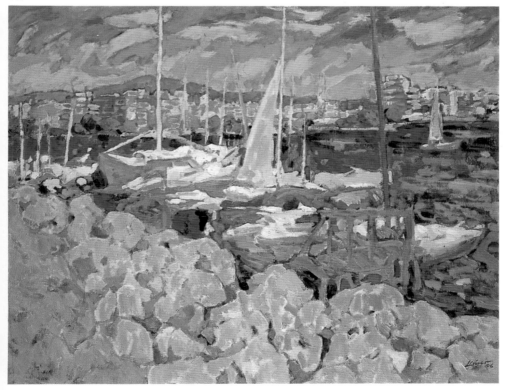

Fig. 147. Teresa Llácer, *Figure*.

Figs. 148 and 149. T. Llácer, two seascapes.

Teresa Llácer's Approach to Painting

As a matter of fact, Llácer is going to do studies or sketches in oil of seascapes. To start with, the study is the first session and the essence of the subject... it's what has to be maintained during all the following sessions when you work on the big canvas.

Llácer says that painting isn't copying a motif or theme, and she adds:

"Painting is capturing the essential, those malleable elements that contain all of nature. In this case they are color, illumination, writing.... This is what is interesting to bring to the canvas. We never make an apple or a woman.... What is important are the forms, the colors that

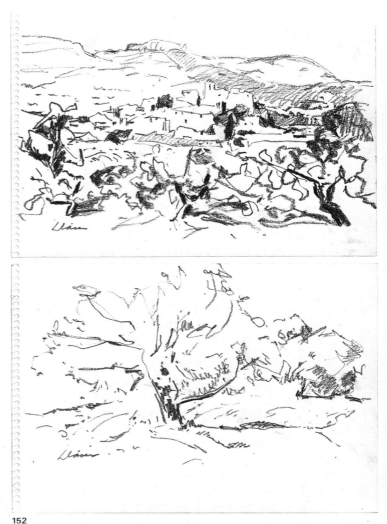

151

150

have inspired you to paint.... In this little study there has been a yellow area from the sky that stood out from the rest of the overall gray tone. This is what you must capture. The emotion that is produced in you."

"I think that one learns to paint by making studies and more studies, catching the essence of a theme and maintaining

152

it during all the sessions, until the moment comes when it functions automatically. This is the basis for painting. If we don't do it like this —Bonnard once said— we begin with an idea and we end up copying nature because it is better than we are, and this is not painting." We agree.

Figs. 151 and 152. T. Llácer always makes sketches of her compositions with a pencil or soft graphite. These drawings already contain the most essential elements of the painting.

Some Studies by Teresa Llácer

153

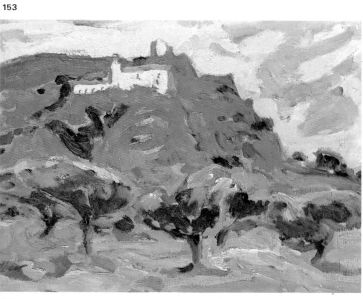

Figs. 153 to 155. T. Llácer, three landscapes.

154

155

Teresa Llácer Paints a Study

It's ten o'clock on a December morning in the Barcelona port. It's a cold, gray day; in a yellowish strip in the sky a few timid rays of the sun cross the expanse reflecting themselves suggestively in the sea.

The painter Llácer has been here for a while and has noticed something. When we find each other, she immediately says:

"Have you noticed that yellow area in the sky? I have the main motif for the study."

With luck, my car is parked close to the point of view she has chosen. We immediately take out everything we need for painting and get down to work.

Teresa Llácer works with a classic easel and paintbox—an Italian model—and with a special wooden palette, covered with a white laminated plastic so she won't have to scrape so much and wear it out. "This way, when I finish I can take the leftover colors off very quickly," she tells us.

For painting studies, if the size isn't bigger than a number 5 of the international measurement, she uses cardboard; only when she works in a number 8 or larger does she begin to work with canvas on a frame. This proportion is more to her liking, as it is more complete. "I prepare the canvases and cardboards with warm and cool colors and at times I use a mixed background of warm and cool tones, depending on what the theme asks. I look for a canvas that gives me the general tone or one that offers a counterpoint, a complementary color that will immediately give me a vibration."

"As in this case the natural color is very gray, I'm going to use a red base, which will stay in the background and will send vibrations to the dominating greens and blues."

"But Teresa," I ask, "you're going out to see nature and now you prepare your canvas?"

"No, of course not. I have them already prepared. I always carry several pieces of cardboard and canvas already pre-

156

pared in warm and cold colors, blues, pinks, purples...."

"So, as far as I can see, you keep in mind a range of predetermined colors whether they be cool, warm, pale...."

"Yes. I think the pictorial problem of a study or a painting should be established immediately. I think that if you confront yourself with a theme, as in this case, outdoors, it's natural that it sets the guideline. I have to study it and if, as now, I see an overall cool gray tone I will use a canvas with a warm color in order to be able to achieve the vibration I mentioned... which is what interests me most about painting."

Llácer paints exclusively with turpentine washes. She generally uses cadmium colors because they are the warmest and the most permanent. She works with several good brands of paint: Titian, Lefranc, Rembrandt. Also, she uses a wide assortment of brushes, for the reason that she paints with clean colors, with the intention of not losing color. In other words, she doesn't use dirty brushes that will spoil the appearance of the tones or their neatness and saturation. It's interesting to see how, before beginning to paint, and still dealing with a study, she makes a brief pencil sketch in a little notebook, which she uses to study the scene, the composition, the illumination, and so on.

Fig. 156. View from the Barcelona port from which the following studies were painted outdoors.

It's also interesting to see in this pencil sketch how she calculates, in an approximate shape, a composition for the section done in gold. Teresa Llácer paints a study in such a way that the third upper part corresponds to the sky and to the shapes that lie on the horizon, while the two lower thirds will be occupied by the sea with its reflections and vibrations. Llácer's gold section is very important, and she keeps this in mind when she composes the painting.

On the cardboard she chose, previously prepared with red and blue stains, she draws directly with a medium brush and with a mixture of burnt sienna and white. The colors are ready on her palette; on the left, the cool range and on the right the warm; she also uses ivory black.

Llácer's style is decisive, and she paints in a feverish rush. She resolves the problems of the study in less than thirty minutes—now wide brushstrokes, up and down, to the right and the left—and there you have it.

"Notice that I have saved the sky's original yellow tone with its yellow reflections in the water, although it's been a while since this outdoor light has disappeared," she adds in conclusion.

157

Figs. 157 to 159. Examine this brief process that Teresa Llácer has followed to create this study of the Barcelona port.

158

159

Josep Sala

160

This is Josep Sala

Josep Sala is one of the most important landscape artists in Spain. He has had many one-man exhibitions in such places as Barcelona, Madrid, Valencia, and Bilbao, etc., as well as in other countries, and has had tremendous critical and popular success. He has exhibited in the United States. He has won important prizes and his paintings are in many of most important European and American museums and private collections.

Fig. 161. J. Sala, *A Rainy Day in San Sebastian*. The chromatic richness and the characteristic environmental quality is extraordinary in Josep Sala's paintings.

161

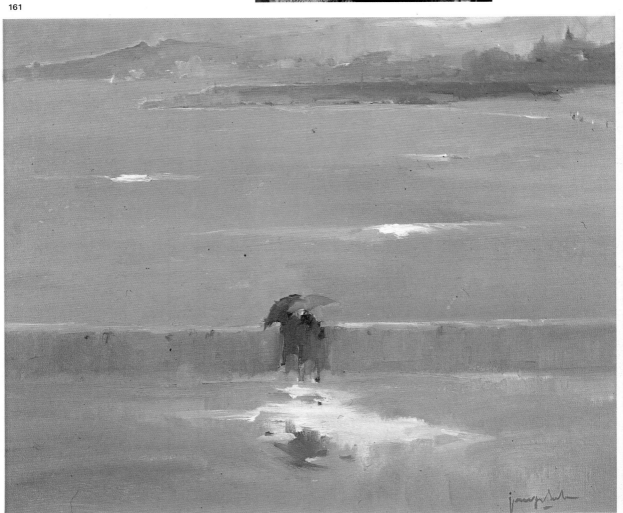

Some Paintings by Josep Sala

Fig. 162. J. Sala, *Seascape*.

Fig. 163. J. Sala, *People at the Beach*.

Fig. 164. J. Sala, *A Corner of the Orchard*.

162

163

64

Josep Sala Paints a Seascape

165

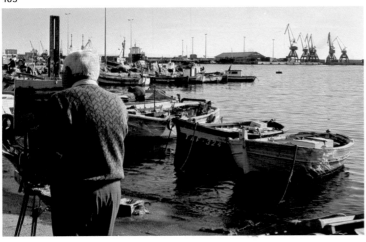

166

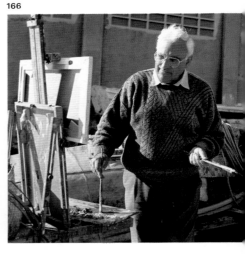

We're in the fishing port of Tarragona, in the place known as "el Serrallo," with the painter Josep Sala who is going to paint us a seascape on a number 10 canvas. It's eleven o'clock on a bright sunny morning.

Sala gets right to the point because he knows his "subject" very well: a group of boats waiting to go out to work, the docks and derricks in the background. He immediately sets up his easel, which is the classic paintbox easel, all in one. Oddly enough, his palette doesn't have a hole to support it with his hand. "I have more space for the mixes," Sala tells us. Also, oddly enough, he puts all of his colors on the upper part of his palette so that he has free space on the right and left of the palette. Look at the photograph.

We should note something truly interesting: Sala doesn't use emerald green or permanent green, or any other green, while the richness and variety in the

167

shades of green in his landscapes is extraordinary. He gets all his greens by mixing yellow, ochre, and orange with blues.

Moreover, Sala always situates his easel in such a way so that the white canvas doesn't get direct sun. He puts the painting in the shade although his subject is completely illuminated by the sun. He customarily paints in dark clothes to prevent the sun from beating on his clothes and reflecting on the canvas, an effect that would alter the painting's colors.

168

Figs. 165 to 171. Sala begins the painting by drawing and painting at the same time. His colors sharpen and become more detailed while he continues forming his shapes. His brushstrokes vary depending on what his theme suggests.

169

Sala takes a number 12 horsehair brush and paints directly; he doesn't draw first. He mixes various colors, depending on what his theme or motif suggests, and starts situating the background: sky colors, docks and derricks... and also, the boats in the middle and the foreground. He doesn't make these first lines or brushstrokes with only one color like other artists, but from the very beginning he establishes his tone—with a definitive "grayed" color. The brushstroke is direct and decisive, very refreshing. He doesn't use oils of any type, he paints exclusively with turpentine—oil of turpentine. In any case, it's a fascinating way to begin a painting. Sala "attacks" the sky now with a warmer gray and a thicker paint that permits him to cut and adjust the shapes in the background. As Sala tells us: "I fill the canvas in order to avoid making mistakes in the contrasts because of the white of the canvas."

The brushstroke has no fixed direction, but in the sea area he works more vertically. When Sala has filled the canvas, he has, as he says "resolved the paint-

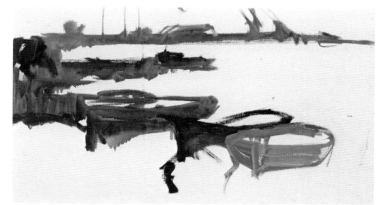

170

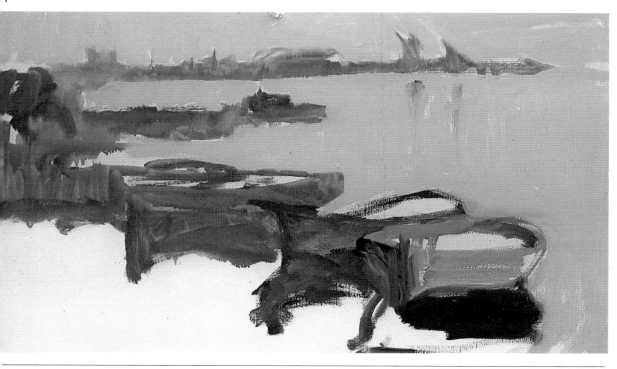

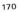

Josep Sala Paints a Seascape

ing's overall mass," meaning the composition and overall structure. From this moment on, he works, drawing and painting at the same time on, this first layer where the turpentine plays an important role, using thick colored paint, adjusting form and color decisively. Sala has a knack for quality, something that makes him a painter's painter. He draws while painting... to construct forms by superimposing paint. He does all this with extraordinary ease. Truly, Sala is a master oil painter.

His colors are basically pale... a mix of complementaries in unequal parts that are brought together with white, as we observe in the creative process of this seascape. But above all, on the palette (see the photograph on page 92) he clearly appreciates the grayish range, which is part of working with pale colors, in other words, grays.

172

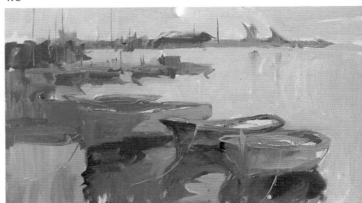

173

Figs. 172 to 174. Josep Sala uses a pale range of colors. Everything is subordinated to the overall gray tone of the work, only accentuated here and there by a warm color to produce the desired vibration.

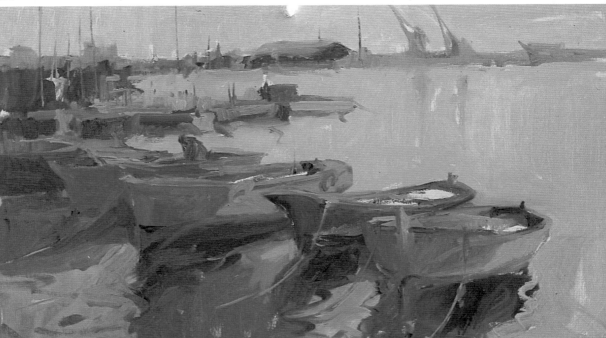

174

175

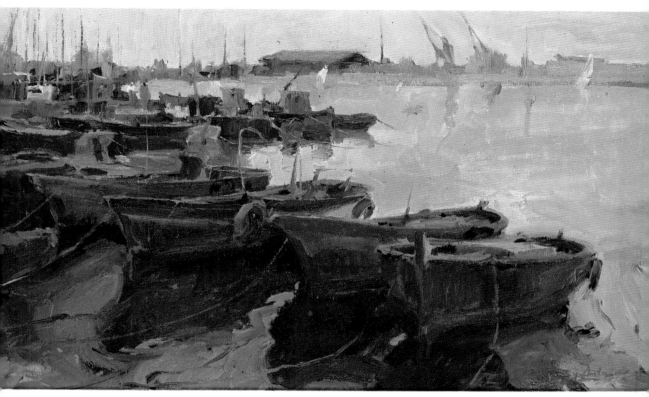

For a painting this size he uses a maximum of three or four brushes, two somewhat thick ones and two medium ones, all preferably flat horsehair. From time to time, in order to maintain a more exact and definite color, he cleans his brushes in the container that holds the oil of turpentine and rubs them on the wood he has below the canvas.

When the work is done, Sala waits until the paint is sufficiently dry so he can return to it on another occasion. Then he will reflect upon it in the studio and finish it outdoors.

It's seven minutes past one. While he gathers his odds and ends, I ask:

"Sala, do you think that one has to look for a subject?"

"No, no... I think that looking is finding. Both things. What happens is you already have the subject in your subconscious... in your head... and this is when you are finding it—I go out to paint and look for the subject which, in a certain way, I already have inside... and I simply awaken it. It's strictly a pictorial problem. Furthermore, when one wants to paint, there is always a subject within reach, you don't have to worry about it."

How right you are, Sala my friend! It's the desire, the study, and the continuous work that helps us resolve these questions, there are no "painteresque" landscapes—the subject lies within the painter.

Fig. 175. The painting is finished. Sala waited until it could dry sufficiently so that on another day, with the same or similar light, he could finish his shapes and fill in the details.

All Styles Are Valid

I want to finish this chapter in which we demonstrated how to paint a seascape, a particular seascape, with an important comment. A comment that reiterates what I have said throughout this book. These days, painting, and art in general, has developed in such a way that it is not possible to dictate a definite way to paint. In the end, the "isms" have finished by discrediting themselves, and frankly this seems good to me. These days, the only important thing is the work's intrinsic quality, independent of its later classification. Everything is valid, everything is acceptable, on the condition that it offers some level of authenticity and is well done.

This is why I say now: there are no formulas and recipes for painting. Look for and you will find your own style. Do what comes naturally. It's the best advice I can give you. I also think that all the concepts and principles contained in this book have led to this idea. This has always been my primary concern—the "leitmotif"—in hopes that I would help you progress with faith and enthusiasm in an activity, a lesson, that I assure you is very gratifying.